MURDER & MAYHEM IN
MISSOURI

MURDER & MAYHEM IN MISSOURI

LARRY WOOD

Charleston London

THE
History
PRESS

Published by The History Press
Charleston, SC 29403
www.historypress.net

Back cover: Image courtesy of Craig Thomas, artist.

First published 2013

Manufactured in the United States

ISBN 978.1.62619.033.7

Library of Congress CIP data applied for.

Notice: The information in this book is true and complete to the best of our knowledge. It is offered without guarantee on the part of the author or The History Press. The author and The History Press disclaim all liability in connection with the use of this book.

CONTENTS

CONTENTS

PREFACE

Writers are often told to write what they know. I've generally followed that advice throughout most of my career, with the slight refinement that I tend to write where I know. In other words, what I know best is my home territory. Writers are also advised that they should write what they most enjoy—what they would write even if they didn't get paid for it. What I find fascinating and would enjoy researching and writing about even if I had to do it for free is history, especially the history of notorious characters and episodes.

Fortunately, what or where I know seems to intersect nicely with what I enjoy because my home state of Missouri has probably produced more than its share of infamous characters and incidents over the years. In fact, Missouri was once known as the "Outlaw State" because of the many desperadoes, such as Frank and Jesse James, that it spawned during the Wild West era following the Civil War, and that trend continued at least through the mobster era of the 1920s and 1930s, when gang members such as Bonnie and Clyde, the Barkers, and Charles "Pretty Boy" Floyd blazed a trail of crime across the state.

This book is a collection of true stories about notorious incidents that happened in Missouri from the pre–Civil War era through the 1930s. I've selected incidents from throughout the state and from different time periods, with the exception that I have not included any incidents that occurred within the past eighty years or so. Events that happened long before I was born seem more like history to me than relatively recent events.

Some readers might think of certain notorious Missouri incidents that seem conspicuous by their absence from this volume and wonder why they were omitted. In many cases, the answer may be that they were not included simply because I have written about them in previous books. Although some of the incidents chronicled here are well known and others are relatively obscure, all of them are incidents about which I have not previously written.

ACKNOWLEDGEMENTS

My hometown library, the Joplin Public Library, served as the base for my research for this book, as it has for most of my previous projects. It was, in particular, the facility through which I obtained materials on Interlibrary Loan, and I want to thank the library's reference staff, especially Patty Crane and Jason Sullivan, for fulfilling those requests.

I also spent time in the local history section of the Springfield-Greene County Library, and I would like to thank the staff, especially John Rutherford and Patti Hobbs, for its help during my visits there.

Thanks go to Andy and Dina Thomas for the sketch used in chapter one and to Steve Maddox for the sketch used in chapter two.

I made two visits each to the State Historical Society of Missouri in Columbia and the Missouri State Archives in Jefferson City during my research for this book, and I would like to thank the staffs at both facilities for their help during my visits. I especially want to mention Anne Cox for her help in providing several photos from the historical society's collection.

I would like to thank Bonnie Shanks of the Linn County R-1 Schools for her important assistance with my research into the murder of the Meeks family.

I wish to extend my appreciation to Matt Clevenger for supplying the photo of Garland Mann and to Matt Caldwell for supplying a copy of the Garland Mann diary.

D. Lee Waterman not only supplied two pictures for the chapter on Billy Martin but also provided valuable insight into the Martin case.

Thanks to Jessica Dickey of the Cape Girardeau County Archives for supplying a photo of the old courthouse.

My wife, Gigi, helped out with some of the research and also served as a proofreader. I want to thank her for those efforts and for her continued support.

Finally, I want to thank The History Press project editor Julia Turner for her excellent proofreading and editing of the manuscript. The book is better because of her professional attention to detail.

Chapter One

THE TURK–JONES FEUD

The Slicker War of Benton and Polk Counties

On August 3, 1840, the men of Montgomery Township in what was then Benton County, Missouri, gathered for election day at their designated polling place, Hiram Turk's store and tavern, about a mile north of present-day Quincy. As was often the case in frontier America, election day at Turk's store was an occasion for high carnival abetted by liquor. Horse races involving gambling went on throughout the day at a nearby track, and some of the men imbibed to the point of intoxication. An argument erupted between Andrew Jones and Hiram Turk's son James over a bet on one of the races, and Jones challenged young Turk to a fight. James picked up a rock and attacked Jones with it, and a general mêlée promptly broke out between Jones and his brothers on one side and Hiram Turk and his sons on the other, with a few additional men joining in the sport. The election day brawl is usually cited as the opening act of the infamous Slicker War that unfolded over the next few years, but it was a mere warm-up for the violent drama to come.

In 1839, Hiram Turk and his family—including sons James, Thomas Jefferson, Nathan, and Robert—had migrated from Tennessee and settled at Judy's Gap, as the Quincy area was known then. Several years earlier, brothers Andrew, Samuel, Isaac, and John Jones had settled a few miles to the northeast on the Pomme de Terre River, also in Benton County. At the time of the 1840 census, Hiram Turk, who had been a colonel in the Tennessee militia, was in his forties, and his unmarried sons ranged in age from mid-teens to mid-twenties, while the Jones brothers were mostly

married and in their late twenties and early thirties. County histories describe the men of both families as strong and physically imposing. The Jones brothers were said to be rough and uncouth in their behavior. The Turks, on the other hand, were supposedly well educated for their time, and the father especially was considered to be refined in manner, at least when he was sober. Both he and the older sons, however, were given to drink and fits of anger, and the sons shared the Jones brothers' love of gambling and horse racing.

In fact, the county histories' claims that the Turks had reputations as dignified men prior to their feud with the Joneses seems dubious in light of their previous history. Back in Tennessee, Colonel Turk, as he liked to be called, had been charged with various crimes, including first-degree murder, but the charges had always been dropped or settled by payments of small fines. In 1839, he had packed up and fled the state to avoid facing a lawsuit over a debt, and the family had been in Missouri only about six months before Hiram and his son James started causing problems in their new neighborhood. On February 18, 1840, James Turk assaulted a man named John Graham with a knife and a club over the Turks' suspicion that Graham had passed Hiram Turk a counterfeit bill, and when authorities tried to apprehend young Turk, he resisted arrest with the help of his father and his brother Tom. Later, James was arrested for assault and the other two for rescuing a prisoner, but Hiram was found not guilty and the charges against his sons were dropped. In April 1840, a couple of months after the Graham incident, Hiram Turk got into a dispute with neighbor Archibald Cock. Accompanied by his son Tom, he broke into Cock's home in a drunken rage, swearing to kill Cock before Tom intervened and restrained his father. Cock sued Colonel Turk for trespass and slander, but the charges were later dropped.

On election day, the Turks' latest belligerent outburst had earned them several more enemies. Although apparently no one was seriously hurt during the election day attack, the Jones brothers promptly pressed charges in circuit court against James and Hiram Turk for assault with intent to kill and against James, Tom, and Robert Turk for rioting. The latter three were convicted of riot and fined $100, but the Missouri governor remitted the fine. Meanwhile, the assault case against James and his father was continued to the April 1841 term.

Abraham Nowell, a farmer who lived in the Turk neighborhood, had witnessed the election day fight and was scheduled to testify against the Turks. He had previously served on the grand jury that had indicted Hiram

and Tom Turk for helping James Turk escape during the Graham incident, and there was also apparently a dispute over land between Nowell and the Turks. James Turk, in particular, let it be known that Nowell should not testify in the assault case, but Nowell did not back down. On April 3, 1841, the morning of the Turks' court date, Nowell started to the county seat at Warsaw in the company of Julius Sutliff and some other neighbors. A few miles north of Quincy, James Turk overtook them and exchanged some heated words with Nowell. Dismounting, Turk drew his pistol, according to later court testimony, and started toward Nowell as if to assault him. Nowell was unarmed, but he took Sutliff's gun, pointed the weapon at Turk, and ordered him to halt. When Turk kept advancing, Nowell shot him dead. Nowell was indicted for murder, but he fled the state, as much, no doubt, to avoid the wrath of the Turks as to escape prosecution.

Incensed over James's death at the hands of Nowell, the Turks soon found a way to strike back at the Joneses and their allies. About the middle of May 1841, two bounty hunters, very likely summoned by Hiram Turk, showed up in Benton County with an 1831 proclamation from the governor of Alabama offering a $400 reward for the capture of James Morton, a relative of the Joneses by marriage who was wanted for murder. Lacking a Missouri warrant, the Benton County sheriff refused to act on the notice because it was so old. Nevertheless, Hiram and Tom Turk joined the two bounty hunters. The four men captured Morton on May 21, 1841, and started north with the prisoner, closely pursued by Morton's friends. At the Missouri River, the Alabama men boarded a steamboat with their captive and headed downstream before their pursuers could overtake them. Back in Alabama, Morton was found not guilty of the murder charge, and he soon returned to Missouri.

Meanwhile, Hiram and Tom Turk were arrested for kidnapping but released on bonds that were meant to ensure their appearance at the July term of court. Events were already astir, however, that would ensure at least one of them never appeared.

In early July, aroused by the Turks' increasingly aggressive behavior, an alliance of their enemies met at Archibald Cock's and decided to rid the neighborhood of Hiram Turk once and for all. About a dozen men attended the meeting, and five of them, including Andrew Jones, signed a pact to kill Turk. Other signees included brothers James and Josiah Keaton, who had fought on the side of the Joneses in the election day brawl.

About two weeks later, on July 17, 1841, Hiram Turk was shot from ambush as he was riding along a road northeast of Quincy in the company

of four other men, while on his way home from attending a lawsuit at the seat of a justice of the peace on the Pomme de Terre. Turk was taken to a nearby farmhouse, and he remained there about two weeks under the care of a physician. He was then taken home, where he died on August 10.

Circumstantial evidence pointing to the identity of Hiram Turk's killers must have existed, or else one of the men who attended the secret meeting must have whispered too loudly, because shortly after Turk's death, Andrew Jones (who had once owned the land where Turk was ambushed) was indicted for murder and four of the other men who attended the meeting were indicted for conspiracy. At Jones's trial in December 1841, spectators flocked into the courthouse, and a long line of witnesses, about sixty for the state and thirty for the defense, paraded to the witness stand. The disparity in the number of witnesses, however, apparently had an inverse effect, if any, on the outcome because Andy Jones was found not guilty.

Outraged by the acquittal of Jones, Thomas Jefferson Turk, a giant of a man at about six feet, six inches tall, decided to take matters into his own hands. In January 1842, Tom, or Jeff as he was also called, organized a vigilante committee with an avowed purpose of driving horse thieves, counterfeiters, and murderers from the area. Turk's committee included not only adventurous young men like himself but also a number of respectable citizens. Prominent among the daring young men were John, Thomas Jefferson "Jeff," and Isham Hobbs, sons of Henry Hobbs, who had been a near neighbor of Hiram Turk in Tennessee and had moved to Missouri about the same time as the Turks, settling south of Quincy near present-day Elkton in what was then Polk County. Isham Hobbs, often called Isom, was a particularly tough character. Strong and athletic, he was about six feet tall and about the same age as Tom Turk. Since arriving in Missouri, he had already been indicted in Polk County for assault with intent to kill in a matter unrelated to the Turk-Jones feud.

Toward the end of January, two men from Johnson County showed up in Benton County accusing Thomas Meadows, one of Andy Jones's friends who had attended the secret meeting at Archibald Cock's house, of stealing their horses. Although Jones and Meadows had recently raced horses with the two men, the stealing accusation later proved false. However, it was enough of an excuse for the vigilante committee to act.

On the afternoon of January 28, the group rode to the home of Andy Jones but found only Andy's brother John and a man named Berry Chapman. They tied Chapman to a tree and openly discussed whether to

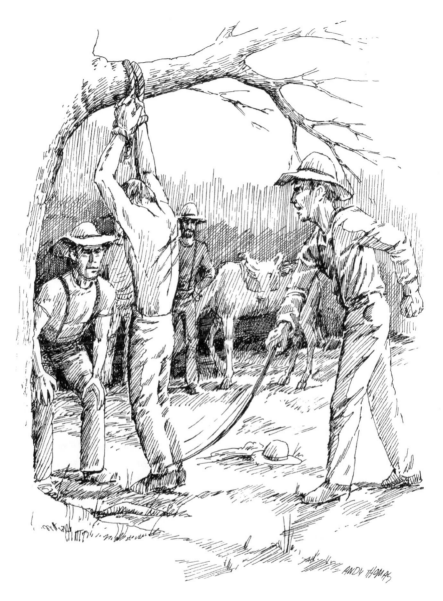

Sketch depicting a slicking. *Courtesy of Andy Thomas, artist.*

kill him or whip him but instead let him off with a mere warning to leave the territory.

They then rode to the home of Thomas Meadows, tied him to a tree, and cruelly whipped him—or "slicked" him, as they called it—with switches fashioned from slender hickory limbs. Thus, the committee came to be

known as the Slickers. After being whipped, Meadows was ordered to leave the country, and he was never heard from again, although accounts differ as to whether he died from his wounds or left the region.

The committee next marched to the home of William Brookshire, arriving about dark. Brookshire had attended the secret meeting the previous summer and, about the same time, had also joined Andy Jones in bailing out an accused horse thief. The men slicked Brookshire until he named Andy Jones as one of the killers of Hiram Turk. He also named Milton Hume and Henry Hodge, who, along with Jones and the Keaton brothers, had signed Turk's death pact.

The vigilantes continued to ride through the night and the next day looking for Andy Jones. They found his brother Isaac and threatened him but turned him loose. They next took Jones's friend Luther White from his home and slicked him.

On the night of January 29, the Slickers rode back to the Quincy area and, the next morning, went to the home of John Whittaker, another attendee at the secret meeting at Cock's. They promised not to hurt him if he would let them search his house, but some of them came back a few days later and gave him a slicking. About the same time, they found Jabez Harrison, yet another attendee at the secret meeting, at a store near where Wheatland now is located and gave him a severe slicking, reportedly cutting him "to the hollow." Harrison gave all the details of the secret meeting and Hiram Turk's murder. He said he and Andy Jones were among those present when Turk was killed but that Henry Hodge was the one who pulled the trigger.

The Slicker War continued to rage during the early months of 1842. The Anti-Slickers, as the Jones faction became known, fought back, not only in the countryside but also in the courts. Both Berry Chapman and Luther White filed charges against the Slickers because of the whippings they had received. Andy Jones tried to kill Tom Turk sometime during February or early March, or so Turk later claimed. About March 21, the local militia was finally called out to restore order. When they cornered Andy Jones at a friend's home, Jones tried to shoot Alex Cox, a Slicker, when he spotted him among the militiamen. Jones's gun misfired, and he was arrested and taken to Warsaw. He was charged in separate cases with attempting to kill Turk and Cox but was released on bond.

The April 1842 docket of the Benton County Circuit Court was jammed with cases. In addition to the charges against Jones, a variety of

other criminal cases, most pertaining to the Slicker War, were to be heard. Abraham Nowell, who initially fled after killing James Turk, had returned and was to be tried for murder. Henry Hodge, Milton Hume, and the Keatons were slated to be tried for killing Hiram Turk, and Archibald Cock was charged with conspiracy. Tom Turk's kidnapping case had been continued from the previous year, and Tom and the other Slickers were charged with assault. In addition, a number of lawsuits, many of them also relating to the Slicker War, were on the docket.

The tension between the opposing factions not only filled the courtroom but also spilled into the streets of Warsaw. When court was in session, Tom Turk and his Slickers rendezvoused at a hotel on Main Street, while the Anti-Slickers made their headquarters at a saloon just down the street. Several fights and near-fights but no major violence occurred.

At Abraham Nowell's trial, the jury heard testimony that James Turk had been a quarrelsome young man while Nowell was a peaceable farmer, and it promptly acquitted the defendant. Not willing, like Nowell, to take their chances in court, Andy Jones and most of the other Anti-Slickers skipped the country before their cases could be decided.

Shortly after the April term ended, Tom Turk and what remained of his family moved to Polk County and settled on land just south of Elkton very near the Hobbs family. Turk also became friends with Alexander Blue, another relative newcomer to area. In the summer of 1842, Blue was fined fifty dollars for starting a fire on the prairie north of Elkton, allegedly with the help of Tom Turk, Isom Hobbs, and John Hobbs. Most of the witnesses against Blue were longtime residents of the region and Baptist church friends of Abraham Nowell. This seemingly innocuous incident apparently rekindled the Slickers' resentment toward Nowell.

In mid-October, Tom Turk and Isom Hobbs visited the Turks' old neighborhood of Quincy and spent the night of the seventeenth on a farm near Abraham Nowell's place. Early the next morning, they moved on to Nowell's farm and crept to within about ninety yards of the house. When Nowell emerged from his house about dawn and leaned down to get a bucket of water, Turk shot at him but missed. Hearing the shot, Nowell straightened up, and Hobbs put a bullet through his chest. Gladis Nowell rushed from the house and held her husband in her arms as he died.

A prominent Anti-Slicker was dead, but a wedge had been driven between Tom Turk and Isom Hobbs because Hobbs felt Turk had missed Nowell on purpose to force Hobbs to do the deed. Later the same day, the braggart Hobbs remarked to a man at a farmhouse not far from Nowell's house that

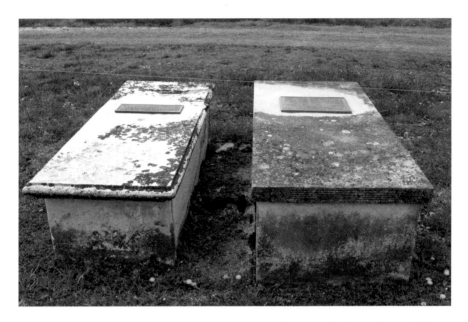

Graves of Abraham and Gladis Nowell at Mount Zion Cemetery, Quincy, Missouri. The plaque on Abraham's stone notes his involvement in the Slicker War and says he lost his life because he believed in law and order. *Photo by author.*

he had killed a "fine deer" earlier that morning, and he also began intimating to others that Turk was a coward.

The feud between the Turk faction and those who opposed them continued to simmer over the next few months, and the citizens of northern Polk County, particularly the Baptists, increasingly allied themselves with the latter group. On March 6, 1843, a group of Anti-Slickers met at the home of William Metcalf, a near neighbor of the Turks. Eighteen-year-old Robert Turk and Archibald Blue, forty-year-old brother of Alexander Blue, went from the Turk home to the Metcalf house late that night and crept to within rifle range. The unlikely duo's mission was supposedly just to scare the people inside, and their first two shots did no damage. However, young Turk fired a third shot that tore through the door, striking and mortally wounding Jacob Dobkins, a young man who had recently married Abraham and Gladis Nowell's oldest daughter.

In response to the killing of Dobkins, Justice of the Peace James Human called out the militia, with his son-in-law, Major Nathan Rains, in command. The group gathered at Metcalf's house on March 9 and marched through the countryside confronting and, in several cases, arresting Slickers. The captured men—Isom Hobbs, John Hobbs, Nathan Turk, and Andrew Turk

(an ally but not a relative of the Hiram Turk family)—were held for a couple of days and then turned over to the Polk County sheriff.

Taken to Bolivar, Isom Hobbs was held on an old assault charge before he was released on bond, but the other three men were released without charges. As the litigious parties on both sides of the Slicker War were wont to do, the men who had been rounded up promptly started filing charges against some of the men who had arrested them, including Nathan Rains, who was court-martialed and kicked out of the militia.

The loudmouth Hobbs started dropping more hints about the killing of Nowell. For instance, Hobbs had always called his rifle "Old Abram" after the gun maker Abraham Hart, whose name was inscribed on it, but he now began repeatedly using the epithet in such a peculiar fashion that people took him to mean he had used the gun to kill Abraham Nowell. Hobbs's loose tongue caused a rift between Isom and some of the other Slickers, and Isom attacked Archibald Blue, who naturally charged him with assault.

In September 1843, on a pretense of hunting for Andy Jones, a group of Warsaw men searched the homes of two Anti-Slicker politicians and whipped a third man named Samuel Yates, but their actions were apparently more of a political move than a renewed outbreak of the Slicker War because there is no evidence Jones was anywhere near Warsaw. For all intents and purposes, the Slicker War was over, but its repercussions would continue to resound for a couple of years.

Andy Jones had gone to Texas in 1842, and in mid-1844, he and several other men were arrested for murdering some friendly Indians near Bonham, Texas. Jones and three of the others were found guilty and hanged. In Missouri, local legend holds that Nathan Turk had tracked Jones and helped bring him to justice, but a Texas newspaper account of Jones's crime and execution makes no mention of Nathan Turk, although he did leave Missouri and was killed in a knife fight in Louisiana not far from where Jones was hanged and not long after that incident.

The festering ill will between Isom Hobbs and Tom Turk finally came to a head during the late summer of 1844. They were working together in a grain field when Hobbs took offense to a remark Tom made about a young woman they both knew. The hotheaded Hobbs challenged Turk to a duel with scythe blades, but Turk backed down.

The relationship between the two men, however, was now more than strained, and rather than deal with the dangerous Isom Hobbs, Tom decided to leave the country. On the afternoon of August 8, 1844, he

went to a blacksmith in the Elkton neighborhood to get his horse shod in preparation for making the trip. On his way back home, he was shot from an ambush in a thicket of willows. His horse continued on to the nearby Turk place, and Tom's mother followed the track of the animal back down the road and, according to the *Warsaw Osage Yeoman*, found her son "weltering in his own blood." The body was taken to a nearby house, and Isom Hobbs, in an apparent attempt to deflect suspicion, showed up to pay his respects. About the same time as Tom Turk's murder, Thomas Draffin, a Slicker who had been in touch with Gladis Nowell and was ready to testify against Isom Hobbs in her husband's murder case, was found dead, shot through the mouth.

These killings were the final straw for Alexander Blue. He had previously stayed quiet to protect Archibald Blue and Robert Turk from prosecution in the Dobkins murder, but his brother had left the area, and Robert Turk was being implicated in the crime by the younger Hobbses anyway. Blue appeared before a Benton County justice and swore out a complaint against Isom Hobbs for Abraham Nowell's murder. Hobbs was arrested and turned over to Alex Cox, the man at whom Andy Jones had shot, for delivery to Warsaw, but Hobbs escaped from his guard and fled the territory. Mrs. Nowell, Alexander Blue, and other Polk County citizens placed notices in the *Springfield Advertiser* offering rewards for his recapture.

Meanwhile, Robert Turk took a different approach to the Hobbs problem. He and his mother had moved to Springfield right after his brother's funeral, but a couple weeks later Robert came back to the Elkton-Quincy area. He knew that Jeff Hobbs was the main person implicating him in the Dobkins murder, and he learned that Jeff had gone to Warsaw with one of his brothers and their father. Fashioning a blind near Quincy similar to the one Isom Hobbs had used to lay in wait for Tom Turk, Robert shot Jeff Hobbs from ambush on August 30, 1844, as the three men were returning home. Jeff lingered a couple days, dying on September 2. Robert Turk was promptly arrested for the murders of both Hobbs and Dobkins, but he escaped from the Polk County jail in early 1845 while awaiting disposition of the cases.

In July 1845, Isom Hobbs was apprehended near Potosi in Washington County, Missouri, and brought back to stand trial in the Nowell case. He escaped again in February 1846 and fled to Mississippi but was soon afterward killed by authorities there while resisting arrest on an unknown charge.

The so-called Slicker War was now but a memory, and many people went about trying to forget it. (Although slicking spread to other Missouri counties in the mid-1840s, notably Lincoln and St. Charles, the "wars" there were never quite as notorious as the one in southwest Missouri.) After Hickory County was formed in 1845 from the parts of Benton and Polk Counties where most of the Slicker problems had occurred, a grand jury met and decided not to further prosecute any cases that had arisen from the Turk-Jones feud, including the pending murder charges against Robert Turk. Almost five years of what Alexander Blue described in a letter to Missouri governor John C. Edwards in June 1845 as "general commotion...blood and carnage" were finally over.

Chapter Two

BURNED AT THE STAKE

The Lynching of Three Missouri Slaves in July 1853

Extralegal executions were common in America during the 1800s, and Missouri had at least its share. While whites were sometimes the victims of Judge Lynch, black men suffered disproportionately from mob violence. In Missouri, this was especially true during the years leading up to the Civil War, when slave owners increasingly feared insurrection or the escape of their slaves to Kansas and other free territories. Slaves who were thought to have committed crimes or otherwise misbehaved were often made object lessons to control the remaining slave population. A slave suspected of murdering a white person or raping a white woman was subject to particularly harsh treatment. At least thirteen slaves were killed by mob violence in Missouri during the 1850s, and almost all the lynchings were in response to alleged murders of white people or sexual attacks on white women. Although hanging was the usual means of execution employed by vigilante mobs in nineteenth-century America, the method used to execute offending slaves became increasingly brutal as the issue of abolition simmered. Of the thirteen known victims lynched in Missouri during the 1850s, five were burned at the stake in four separate incidents.

The case of a slave named John, who was burned in Saline County during the summer of 1859, has been well documented (e.g., *Missouri Historical Review*, April and July 1995). However, less has been written about the other three cases. One was the burning to death of a slave named Giles in Lincoln County in January 1859 for having killed his master during a heated argument. A brief account of this event appears in the 1888 *History of*

Lincoln County, Missouri. The other three burnings involved but two incidents, as one of them was a double lynching. These two incidents, occurring within twenty days of each other during the summer of 1853, are the subject of this chapter.

On Sunday, July 3, 1853, twenty-one-year-old Elizabeth Rains was home on her rural Pettis County farm northeast of present-day Sedalia with her three young children while her husband was attending church when a black man about her own age showed up and tried to force himself on her. She broke loose and raced from the house toward a woodpile. He grabbed a heavy, forked hickory stick that was being used to prop up the limb of a tree, and as she reached for an axe, he struck her a blow with the stick and kept beating her until she was dead. He then clubbed her six-year-old son, James, to keep him from telling what had happened and left him for dead. Annoyed that Elizabeth's two younger children were, as the assailant reportedly said later, "crying about their mother," he also abused them and tossed them in a fence corner.

When Elizabeth's husband, twenty-seven-year-old John A. Rains, got home, he discovered his wife dead beside the woodpile and James so badly hurt and bruised that it was thought he might not recover. The boy, however, rallied enough to identify the attacker as a slave named Sam belonging to neighbor Henry France.

Apprehended soon afterward, Sam at first denied the deed and then reportedly blamed it on his brother. He finally admitted to the crime but insisted that Henry France's son William had put him up to it. Twenty-one-year-old William France was taken into custody along with Sam, and both were taken to Georgetown, the seat of Pettis County, and lodged in jail.

The next day was set aside for Elizabeth Rains's funeral service, but on Tuesday, July 5, the two prisoners were brought before a county magistrate for a preliminary hearing. By this time, Sam had changed his story to exonerate his young master, and France, although still under suspicion, was released. Attorney George G. Vest, later a U.S. senator, was appointed to defend slave Sam, but before his examination was complete, an unruly gang trooped into Georgetown, threw a chain around the prisoner's neck, and took him from the courthouse by force with the intention of burning him to death. The mob was led by George Anderson, Charles P. Farris, and other men from Heath's Creek Township, where the Rains family lived. County officers and other leading citizens intervened, advising the boisterous throng against precipitous action. One of the prominent men who reportedly spoke against the lynching was General George R. Smith, who later founded

Sedalia. After much parleying, the mob allowed the prisoner to be taken to the county jail, but he had scarcely arrived before the throng descended on the calaboose with renewed determination to take possession of the accused. After further mediation, the indignant horde finally relented, agreeing to postpone any action until July 13, when an official disposition of the case was promised. The crowd insisted, however, that one of their own must be allowed to guard the prisoner during the interim.

Although Sam had been provided counsel, the facts suggest that most of the men who argued against summary justice merely wanted to postpone the lynching, not prevent it. Some did not want to execute Sam on the spot because they wanted to interrogate him further to try to ascertain whether William France had indeed incited him to commit the crime. France and his father had previously caused trouble in the neighborhood and were considered disreputable men. If William had helped instigate the crime, he could be held liable, but if not, community leaders still saw the murder of Elizabeth Rains by one of the France slaves as a good reason to drive the France family out of the territory. Some of the citizens also wanted to postpone the lynching so they would have time to round up other slaves of the county and force them to witness it as a warning against committing similar crimes. Whether July 13 was set during the standoff with the mob on July 5 as a firm date for the execution or was only announced as a time when some definitive action would be taken is unclear, but there must have been a tacit agreement between the mob and the prominent citizens that the lynching would not be vigorously opposed if it were postponed until the later date because word spread during the second week of July that the execution would take place on the thirteenth.

On the designated day, people flocked into Georgetown in anticipation, and masters brought their slaves in from the countryside so they would have to watch the gruesome spectacle. One of the men who trekked to Georgetown in response to the rumored lynching was H.C. Levens of neighboring Cooper County. "I found the town crowded with people," recalled Levens years later, "and among them a large number of the colored race, their masters wishing them to witness the execution in order to deter them from committing a like crime."

A mood of tense expectation hung over the crowd milling about Georgetown until a company of about one hundred riders, composed mostly of the same men who had formed the mob eight days earlier, came galloping into town. They broke the prisoner out of jail and herded him outside with a rope tied around him. General Smith again addressed the

mob and the rest of the citizens gathered for the ghastly occasion. He gave a brief account of Sam's crime but, according to Levens, took no position on whether the man should be lynched. The crowd's lust for vengeance was so strong that no one else dared to oppose the execution either. The only question put to the people was whether to hang or burn the prisoner, and they voted overwhelmingly for incineration.

With the rope still around him, Sam was trotted to a preselected execution site a few hundred yards north of town, and the assembled mass thronged behind, agog to witness the Saturnalian sacrifice. The captive was chained to a sapling, and kindling and sticks were placed in a circle around it as spectators vied for a clear standpoint, some even climbing nearby trees to get a better view. A fire was lit, reportedly by Elizabeth's brother Robert Williams and one other man, and the blaze soon enveloped the helpless victim. "He made considerable noise," recalled Levens, "begging to be released, after he felt the torture of the flames. The chains around his wrists soon cut through the flesh to the bones, and being no longer able to stand, [he] swung by the

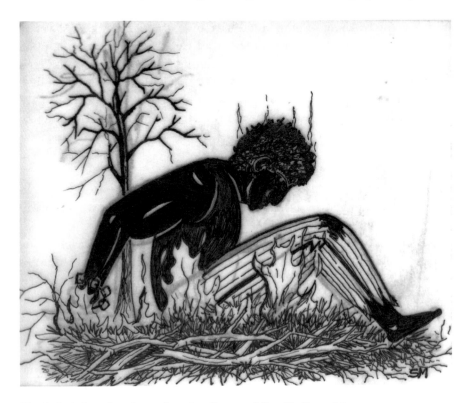

Sketch depicting a burning at the stake. *Courtesty of Steve Maddox, artist.*

chains in a doubled up condition. There were a great many people present at the burning, but many, after the fire was set, turned and walked away, and I have afterwards regretted that I had witnessed such a horrible sight."

According to the 1882 Pettis County history, slave Sam was "soon scorched to a cinder," and the sheriff afterward buried his remains on the spot.

The same day as Sam's lynching, the citizens of Heath's Creek Township drew up a resolution compelling the France family to leave the county within ten days and leave the state within thirty days, and they appointed a committee of at least nineteen men to carry out the provisions of the resolution. Reasons cited for the resolution included William France's suspected instigation of Elizabeth Rains's murder, depredations the Frances had committed on livestock, threats they had made to their neighbors, and the bad example they set by talking to their slaves about the questionable virtue and chastity of certain white women. The France family did pack up and leave Pettis County, but they were still in Missouri, living in Bates County, seven years later.

On the evening of July 16, just three days after Sam's burning, slave Colley and slave Bart approached the home of Dr. John Fisk in Jasper County, 160 miles southwest of Georgetown, with plans to carry out a malevolent scheme they had hatched. Dr. Fisk had received a large amount of money from Colley's owner, John B. Dale, in a business deal a few days earlier, and Colley, who knew of the transaction, decided to murder Fisk for the money. Colley was also angry reportedly because the doctor had scolded him at least twice in recent days for the slow pace with which he had performed certain chores. Both Colley and Bart had been purchased not long before from Cherokee Indians, and the two apparently were not accustomed to demanding taskmasters. Colley enlisted Bart, who belonged to neighboring farmer John J. Scott but had recently run away, to help carry out his murderous plan, and Bart agreed on the condition that they also kill their owners and make their escape to the North.

The two men reached the neighborhood of Dr. Fisk's home about dusk. Bart stayed back while Colley called at the house alone and told the doctor that Mr. Dale's baby was sick and needed medical attention. The doctor grabbed his bag, mounted his horse, and headed down the road toward the Dale farm with Colley following behind on foot. A short distance from the house, Bart sprang up out of the brush and knocked Fisk from his horse. Colley then rushed up behind the doctor and hit him in the back of the head with an axe that he had previously concealed. When the first blow did not kill Fisk, Colley struck him a couple of more blows above the eyes, and the doctor fell down dead.

The two rifled through Fisk's pockets but got only two or three dollars. Having found but little money on Fisk's person, they skulked around in the woods for several hours before going back to the doctor's house about midnight. They barged in and, according to a newspaper account published about ten days later, knocked Mrs. Fisk down and raped her, each taking his turn while the other held her down. After violating Mrs. Fisk, they reportedly killed her with the same axe they had used to kill her husband and choked her two-year-old child to death. They then plundered the premises, finding thirty dollars and a pocket watch, and set fire to the house.

After the crime, the pair hid their ill-gotten treasure in a corncrib before parting ways. Colley went back to his cabin at Mr. Dale's farm, but Bart took to the woods to try to make his getaway, abandoning the plans he and Colley had hatched to kill their masters before fleeing. Early the next morning, Colley put on a different set of clothes from the ones he had worn the day before and went out onto the prairie to look for some stray horses. He came back shortly afterward and told the Dale family that Dr. Fisk's house was on fire. Someone from the Dale household started toward the Fisk home and found the doctor in the road where he had been brained to death. At the Fisk property, the bodies of the doctor's wife and child were found among the ruins of the burned home.

News of the atrocity spread quickly, and people from the surrounding neighborhood hurried to the Fisk place. Suspicion was immediately directed toward Colley, and to test him, he was summoned and told to guard Dr. Fisk's body and prepare it for burial. Although he had previously prepared bodies for burial, he reportedly became nauseous and nervous, and he begged to be excused from the chore. Accused of the crime, he denied any knowledge of it, but he was arrested nevertheless and taken back to the Dale farm. Mrs. Dale noticed that Colley had changed clothes, and the bloodstained clothes he had worn the day before were found in his cabin.

When Colley still denied knowing anything about the heinous deed, Dr. Fisk's enraged neighbors took him to a nearby gate, looped a rope around his neck, and drew him up from the overhead beam, threatening to hang him on the spot if he didn't tell what he knew about the crime. Still, he held fast to his claim of innocence. Exasperated, the neighbors appointed three men to guard and interrogate the prisoner, or "talk to him," as a *Carthage Banner* article reprinted in an 1876 atlas of Jasper County phrased it. Meanwhile, the rest of the gathering gradually dispersed.

During the interrogation that followed, Colley finally told the three men the horrible details of his and Bart's crime. He also told where the stolen

loot was located, and it was found in the corncrib, where he said it would be. Colley was then taken to nearby Carthage, the seat of Jasper County, and held while a search for Bart was undertaken.

About fifty or sixty men turned out to scour the countryside for Bart. They found several traces of the fugitive, but he continued to elude capture. One evening, about July 26, as the posse closed in, some children found him hiding in a thicket of sumac bushes near the present-day community of Galesburg in northwest Jasper County and reported their discovery to a group of men at a house nearby. The men surrounded Bart's hiding place on horseback and quickly took him prisoner. He had been on the run for ten days, but compelled to travel clandestinely and not being familiar with the territory, he had not even made it out of the county. Although armed with a rifle and pistol, Bart offered no resistance.

Steadfastly denying the charges against him, the captive was taken back to the courthouse in Carthage, where, on July 27, a committee of citizens was selected to hear his and Colley's case. The committee members unanimously favored the death penalty for both men, but the vote was split on the mode of execution, some favoring hanging and some arguing that hanging was too good for them and that they should be burned. Many area residents had thronged into Carthage after hearing the news of Bart's capture, and the committee finally agreed to put the question to the people as a whole. Outside the courthouse, forty-two-year-old James H. McPhatridge, a former county judge, mounted a platform on the east lawn to address the people gathered in the street and elsewhere on the east side of the square. Two men were stationed to McPhatridge's left near the northeast corner of the square, and two other men were positioned nearby. Announcing that a vote was to be taken, McPhatridge told everyone who preferred hanging to march between the first two men and for those who favored burning to march between the other two. Many spectators declined to vote, but among those who participated, the vote was approximately a two-to-one ratio in favor of burning. It was then proclaimed that the incineration would take place three days later, on July 30.

Word of the planned executions spread, and according to local histories, the largest crowd in Jasper County history up to that time assembled at Carthage on the appointed day in anticipation of witnessing the dreadful spectacle. People came not only from Jasper County but also from surrounding counties and some from as far away as Indian Territory. An eyewitness, Timothy Meador, recalling the incident years later, estimated the gathering at between three and four thousand. Among the crowd were

many slaves who had been brought into town by their owners to witness the executions

About ten o'clock on the morning of the thirtieth, the gathered throng, according to a contemporaneous newspaper account, "took the negroes out of the hands of the officers." If the sheriff or other law enforcement officials offered any resistance, however, it must have been very token because later reports make no mention of any confrontation between the mob and law officers. They instead seem to suggest that the so-called examination the black men had received before the citizens' committee three days earlier was all the due process that county officials felt obliged to provide them. (Later reports also place the time of the lynchings at about 3:00 p.m., not 10:00 a.m.)

The two prisoners were herded northeast of the public square to a hollow along present-day Macon Street where the hillsides formed a sort of natural amphitheater. Spectators lined the hillsides, and the slaves who had been brought in from the countryside to witness the executions were given positions close to the condemned, where they might have an unobstructed view. Three iron bars were driven into the ground at such distances apart so that each man could stand between two of the bars with his arms just able to reach each. The leaders of the mob started to tie the men's arms to the bars with rope when they realized that the fire might burn the ropes. One of the leaders supposedly shouted, "Two dollars and a half for trace chains," and several chains were promptly produced.

Colley and Bart were bound with the chains, dry sycamore wood was piled around them about waist high, and thin shavings and other kindling were added. Four or five people then stepped forward at the same time to light the fire, according to Timothy Meador, but the *Carthage Banner* article claimed that two slaves lit the fire. (If true, they were no doubt compelled to do so.)

Reports also differ concerning the reaction of the two men as they were on the verge of incineration. A contemporaneous newspaper account said that both of them became terror-stricken, confessed their crimes, and pleaded to be released but that Bart quickly recanted his confession as soon as he realized it was futile and once again defiantly proclaimed his innocence. The *Banner* article, on the other hand, said, "Mr. Dale's negro stood the trying ordeal bravely and sang songs until the flames suffocated him, but the other colored man pleaded piteously for release." To the best of Meador's recollection, both men bore the terrible agony stoically: "One of the men gasped twice and the other cringed and cowered, but neither groaned, shrieked nor said

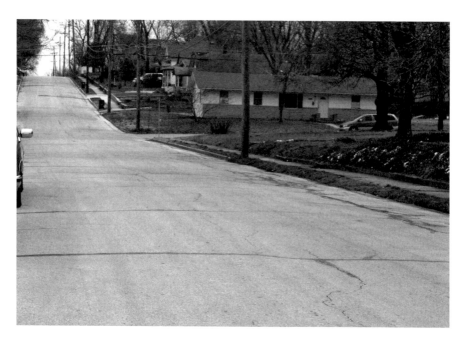

Approximate spot on East Macon Street in Carthage where slaves were burned in 1853, as it appears today. Note the hillsides forming what was described in the 1800s as a "natural amphitheater." *Photo by author.*

a word and there were none of the horrors one might imagine." All reports agree that after the flames reached the two men, they struggled only briefly and then sank down and died quickly. Within an hour, the fire had burned down, and there was little left of the incinerated bodies.

Interestingly, the author of the *Banner* article concluded his account of the lynchings with the incongruous observation that a thunderstorm came up afterward and many of those in attendance got drenched before they could reach their homes, as if the minor inconvenience suffered by the spectators was as noteworthy as the fact that they had just seen two human beings roasted alive.

Just as no one spoke up against the burnings in Pettis County and Jasper County at the time they occurred, few, if any, commentators dared to condemn them afterward. Although newspapermen of the day and county historians of later years both felt obliged to lament the brutal method of the vigilante executions, they tried at the same time to justify or excuse the mobs on the grounds that the crimes committed by the slaves had been exceedingly heinous and that an example needed to be

set to discourage what was supposedly an alarming trend of black men raping white women.

For instance, the editor of the *Boonville Observer* admitted in the wake of the Pettis County burning that some people would probably find the vigilante execution "cruel, if not barbarous," but he argued that the nature of Bart's offense and the "frequent attempts of late years, of negroes to rape white women" could partially excuse the mob's action. The newspaperman reached the dubious conclusion that, had Bart been a white man, he would have suffered the same fate.

Similarly, the author of the *Carthage Banner* article felt that, although the tragic double lynching of July 1853 might seem "inhuman and awful" to his readers, "extenuating features" were involved, and "we can charitably excuse the act on the ground that the crimes perpetuated by the negroes were almost without parallel."

Chapter Three
STRANGER THAN FICTION

The Romantic Escapades of Desperado Billy Martin

In September 1881, after fugitive William Franklin Martin of Laclede County, Missouri, was recaptured in Tennessee, the editor of the *Springfield Patriot Advertiser*, in reporting the event, allowed that Billy's escapades and wanderings were so many that the paper didn't have room to recount them all. The passage of 132 years and the fact that Martin added to his catalogue of adventures after the editor's observation makes the task of chronicling his story perhaps even more daunting today, but I will make a start.

Martin's misdeeds began at a wheat threshing in the summer of 1878 when he was just eighteen years old. Billy and his father, James Martin, were working on a farm northwest of Lebanon on July 22 with brothers Jesse and Charles Prewitt, both about Billy's age, when a dispute that Billy had previously had with one of the young men was renewed. One of the brothers grabbed a pitchfork, and Billy pulled out a pistol. In the mêlée that followed, Charles Prewitt was killed and Jesse, his older brother, was wounded. Billy Martin was arrested and, according to the 1889 Laclede County history, charged with murder. The only surviving court document pertaining to the case, however, is an indictment for Billy's assault against Jesse Prewitt, a charge of which he was acquitted in February 1879.

Although the county history claimed that Billy was "not regarded as a quarrelsome person," he had scarcely gotten clear of the Prewitt scrape before he got into another feud, this time with his uncle, twenty-seven-year-old George W. Mizer. George and his wife, Anna Clinkenbeard Mizer, had, according to her later testimony, experienced "several little difficulties" in

their marriage. In fact, the twenty-six-year-old Ann had been accused of being too intimate with other men, particularly twenty-one-year-old George Rollins, and Mizer had reportedly threatened to divorce Ann and take their kids away from her. Mizer thought that his sister's son, Billy Martin, was one of those spreading rumors about the Mizer marital difficulties. Among the things Billy had supposedly said about Ann was that he (Billy) could do whatever he wanted with her. Confronting his nephew on June 4 at his home in Goodwin Hollow north of Lebanon, George told Billy he knew enough to hang him and that if Billy didn't stop talking about Ann and him (George), he was going to tell authorities what he knew. (It's not clear whether this was a reference to the Prewitt case.) Martin denied spreading the rumors, and the two men had to be restrained to keep them from coming to blows or pulling their pistols on each other. A few days later, Billy reportedly told a neighbor that if Mizer didn't leave him alone and didn't stop abusing Ann, he was going to hurt George "the worst he was ever hurt." Billy remarked that he had lain in jail before and he could do it again. The dispute between George and Billy naturally caused a rift between George and his sister, Sarah Jane Martin, who took her son's side in the argument, urging him to stand up to her brother.

Gravestone of George Mizer at Mizer Cemetery in Laclede County. *Courtesy of D. Lee Waterman.*

On Monday afternoon, June 9, George was plowing in a field near his house with his brother, Tom Mizer, when a shot suddenly rang out from a nearby patch of woods and George fell mortally wounded. Tom ran to his brother from sixty yards away, but George died as soon as he got there. A coroner's inquest was begun at the scene of the crime, and Billy Martin was among those who showed up at the inquiry on the tenth. Later that day, George Mizer was buried at a nearby cemetery. The coroner's jury was unable to reach a verdict, but a second one convened at Lebanon on June 12. It lasted well over

two weeks as the jurors attempted to ferret out the facts of the case and to identify the murderer.

Based largely on the threats Martin had made and other circumstantial evidence, he was finally arrested in July and formally indicted for murder at the August term of circuit court. His mother was also arrested as an accomplice for supposedly encouraging him in the crime, but she was released on bond and later found not guilty.

Martin's trial was set for the February 1880 term of Laclede County Circuit Court, and it began on the seventh. A long line of witnesses, 68 for the state and 112 for the defense, paraded to the stand during the proceedings. The defense sought to establish an alibi for Martin in order to undercut the prosecution's circumstantial case. For instance, both Martin's fifteen-year-old sister and twelve-year-old brother swore that Billy was home all afternoon on the day of the murder, but Martin's multitude of supporters apparently failed to sway the jurors. Closing arguments ended on the evening of February 13, and after deliberating for over an hour, the jury came back with a verdict of guilty as charged.

The defense immediately filed a motion for a new trial, and the judge gave the defense and the prosecution six weeks to gather additional evidence before hearing the motion. The process ended up taking much longer than six weeks, as both sides accumulated a whole stack of affidavits, mostly attesting to or swearing against the reputation for truthfulness of witnesses who had testified at the trial.

Meanwhile, Billy bided his time at the Laclede County jail in Lebanon, where Margaret "Maggie" Wilson, the fifteen-year-old niece of Sheriff Jacob Wilson, was occasionally detailed to feed the prisoners. Billy had begun wooing her even before his trial by sliding notes to her when she made her rounds. At first she didn't respond, but gradually, he began to win her heart. Discovering the budding romance shortly after the trial concluded, the sheriff sent his niece to stay with another couple in Lebanon. However, the correspondence between the young lovers continued clandestinely through the aid of Maggie's friends.

When the hearing on the motion for a new trial was finally held in August, the judge overruled the motion and sentenced Martin to hang on September 24. On August 7, as the prisoner was being led back to his cell after the sentencing, an old man who had been on the jury that indicted Martin started heckling him, and Billy, despite being handcuffed and shackled, attacked the man and knocked him down. A mob swarmed the prisoner and was ready to lynch him on the spot before other citizens intervened.

Old jail in Lebanon where Billy Martin was incarcerated, used today as a museum. *Photo by author.*

Billy's lawyers appealed to the Missouri Supreme Court on August 9. The main bases for the appeal were that the state had wrongly introduced as evidence Billy's previous indictment for felonious assault in the Prewitt case and that the state had wrongly called attention to the fact that Billy's mother had not testified in his defense. The high court stayed the execution on September 10 and promised a ruling on the appeal by January 1, 1881.

When Maggie was allowed to come back to her uncle's residence in September 1880, the romance between her and Billy blossomed stronger than ever, but Sheriff Wilson did not seek reelection in November. Knowing that their time together would end when the new sheriff took office and not willing to take their chances with the supreme court, Billy and Maggie made plans for her to free him so that they could run away together. On the morning of November 16, while her uncle was absent, Maggie unlocked Billy's cell and handed him a Winchester rifle she had secured at his request. The two walked out the door together and made their way to Billy's home near present-day Eldridge, where the family had moved after James Martin was forced to sell his farm on Mountain Creek to finance his son's defense.

The couple spent about ten days at the Martin home. Even though search parties reportedly went out scouring the countryside right after

Billy's jailbreak, no one attempted to arrest him during his sojourn at his parents' house. According to his later statement, it was common knowledge in the neighborhood that he was there, and he and Maggie even tried to get married but, because of the girl's age, could find no one who would marry them. However, Billy decided about November 25 that he had better not risk staying at home any longer.

He secured two horses, and, with Maggie dressed as a boy and her hair cut short, the love-struck pair rode away together. They traveled south into Arkansas and then east into Mississippi, finally landing at Martin's Station, Virginia, where the lovebirds got married in early December and Billy, using the name "Cross," found work in a blacksmith's shop.

In January 1881, two detectives from North Carolina came into the shop and, mistaking Billy for a fugitive from their state, started to arrest him. Assuming they wanted him for the Missouri case, Billy struck one of the men with a hammer, hit the other with a hot iron, and made his escape.

He and Maggie immediately left for Piney Flats, Tennessee, where Billy assumed the alias of Frank Ratcliffe and started working on a farm. In late August 1881, Richard Goodall, the new Laclede County sheriff, learned of Martin's whereabouts through letters Billy had written to a relative in Arkansas, and Goodall started for Tennessee to arrest the fugitive. Arriving at the town's combined post office and general store and being informed that "Ratcliffe" occasionally frequented the place, Goodall hung around for several days until Billy finally made his appearance on August 30. Before Martin knew what was happening, according a newspaper account a few days later, he was "in handcuffs and was listening to the warrant from the State of Missouri endorsed by the Governor of Tennessee."

On September 2, Goodall arrived in St. Louis with the prisoner, accompanied by his pregnant young bride, and the party was met by Deputy Wickersham of Laclede County. During the stopover, both Billy and Maggie gave interviews to St. Louis newspapers. Under a story headed "Stranger Than Fiction," Maggie admitted that she had let Billy out of jail because she had "learned to love him months before" and was "determined if possible to keep him from hanging." Billy, for his part, said Maggie had stood by him and he meant to stand by her. He denied having killed George Mizer and said that he thought Bob Clinkenbeard, Ann's younger brother, had probably done the deed, although of the several young men that Billy's defense team had hinted at during his trial as possible perpetrators of the crime, George Rollins and not Clinkenbeard was the primary suspect.

Late that night, the journey to Lebanon resumed aboard a Frisco train, and during the wee hours of the morning on September 3, while Goodall and Wickersham dozed off, Billy jumped from the train when it slowed going up a hill near Dixon. The train was immediately stopped and a search undertaken, but Billy, despite being handcuffed and shackled, could not be found. A sympathetic hunter soon freed him of his shackles, and he made his way to his father's house.

Billy and Maggie Martin, as they appeared in later life. *Courtesy of D. Lee Waterman.*

Maggie, meanwhile, was brought on to Lebanon and was held in the county jail for aiding her husband's escape. Released on bond, she was rearrested on a charge of stealing her uncle's rifle and money.

In October, the Supreme Court, agreeing with Billy's lawyers that the state should not have called attention to the Prewitt case, granted Martin a new trial. Billy then surrendered to Sheriff Goodall on November 11 at his father's home. Maggie, who had recently been released from jail, gave birth to twin baby girls on November 17.

In January 1882, Billy was granted a change of venue to Dallas County, and at his April trial in Buffalo, he was found not guilty. Commenting on the verdict, a Springfield newspaperman observed, "The devotion to Martin, through all his trials, that has been exhibited by the sheriff's niece is truly remarkable, and is now rewarded by an opportunity for them to live in peace a wedded life begun under such adverse circumstances."

However, the couple's wedded bliss was short-lived. In February 1885, Billy was arrested in Laclede County for stealing a pair of horses. He was convicted in August and sent to the penitentiary in Jefferson City for a term of four years. He was discharged on August 3, 1888, under the three-quarters rule and went back to Laclede County. The *History of Laclede County*, published the following year, perhaps summed up the feelings of many when it said, "For a man so young the career of William Martin has been a remarkable one."

Apparently, Billy and Maggie finally did attain the peace in their wedded life that the Springfield newspaperman had forecast for them. At the time of the 1900 census, they had settled down on a farm near

Gravestone of Maggie Martin at Hufft Cemetery, Eldridge, Missouri. *Courtesy of Find a Grave.*

Eldridge, and the wayward Martin, who had professed no religious preference at the time of his 1885 incarceration, eventually became a preacher. The family moved away from Missouri during the 1920s, and Billy died in Washington in 1935. Maggie came back to Missouri and was buried in a cemetery at Eldridge when she passed away in 1960 at the age of ninety-five.

THE GREATEST SENSATION IN MISSOURI HISTORY

The Assassination of Jesse James

When an alarm was given after a man was shot dead in a home at the corner of Thirteenth and Lafayette Streets in St. Joseph, Missouri, on the morning of April 3, 1882, one of the first people to arrive on the scene was a reporter for the *St. Joseph Evening News*. The victim was lying on the floor of the front room still oozing blood from a gunshot wound to the back of his head when the newspaperman entered the home. Stepping around the corpse, the reporter went into the kitchen and found a woman and two small children. At first the woman refused to say anything about the shooting and begged the reporter not to put anything about it in the paper. Finally, she identified the dead man as her husband and said his name was Howard. He had been killed, she said, by two young men named Johnson, who had been staying with them. Within minutes, though, the "dirty little coward[s] who had shot Mr. Howard" reappeared on the scene and said their name was actually Ford and that the dead man was none other than the infamous outlaw Jesse James. They said they were proud to have killed the man "known all over the world as the most notorious desperado that has ever lived" and that they meant to collect the reward that had been placed on his head.

Ever since the Civil War, Missouri had been infested with outlaws and plagued by frequent bank robberies and train holdups. The lawlessness was, in large part, a carryover from the war because many of the outlaws were former Confederate guerrillas who had not adjusted to civilian life. Authorities had been helpless to do much about the situation, partly because many people in the

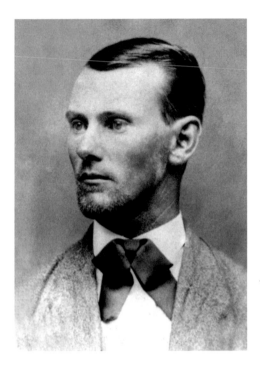

Jesse James, circa 1880. *Author's collection.*

state, especially ex-Southerners, distrusted the banks and railroads owned predominantly by Northern capitalists and secretly sympathized with or, in some cases, openly supported the outlaws. This state of affairs existed especially in and around Jackson County, where Confederate guerrilla leader William Quantrill and his notorious band, including Frank and Jesse James, had made their headquarters during the war. Jesse James, in particular, had gained almost hero status among many people in the state because of his daring exploits in bank and train robbery.

The tide began to turn in 1880 when Missouri elected a new governor, Thomas Crittenden, who announced during his inaugural speech that he planned to eradicate the outlaws from the state. In July 1881, after a train holdup in Daviess County that resulted in the murder of two men and appeared to be the work of Jesse James, Crittenden, in concert with the railroads, offered a $5,000 reward for the outlaw's arrest and another $5,000 if he were convicted. In early September 1881, as if in defiance of the governor's action, Jesse pulled another train robbery at Blue Cut in eastern Jackson County. His brother, Frank, helped out in the caper, and other participants included Dick Liddil, Jesse's cousins Clarence Hite and Wood Hite, and recent recruit Charley Ford.

However, the Blue Cut job would prove to be Jesse's last. In response to the crime, Crittenden announced that if ordinary means could not bring the outlaws to justice, then "heroic treatment" would be resorted to. Public opinion began to turn against the outlaws, and just as importantly, the gang members began to turn against one another. In late September, former gang member William Ryan was convicted in Jackson County for his part in the gang's 1879 Glendale train robbery after Crittenden pardoned

another former gang member, Tucker Bassham, to serve as the state's chief witness. Then, in early December 1881, Dick Liddil and Wood Hite got into an argument at the Ray County home of widow Martha Bolton, sister of Charley Ford. The quarrel was ostensibly over the split of loot from the Blue Cut robbery, but the real problem apparently stemmed from the two men's mutual interest in Martha Bolton. They pulled their guns and started shooting, and Hite was killed, either by Liddil or possibly by twenty-one-year-old Bob Ford, younger brother of Charley Ford, who walked in during the gunfight and also started firing.

Liddil now had both the law and Jesse James to fear. Even before the gunfight, Liddil had worried that the increasingly paranoid James might dispose of him if he suspected him of betrayal, and now that he had killed Jesse's cousin, he decided to take his chances with the law.

In early January 1882, he sent Martha Bolton as his emissary to Jefferson City, where, dressed in black and heavily veiled to disguise her identity, she met with Governor Crittenden to negotiate Liddil's surrender. Martha's brother Bob Ford had been trying to hatch a plan to capture or kill Jesse James ever since Crittenden offered the huge reward, and during her meeting with the governor, she let him know of Bob's ambition. On January 13, Crittenden met with Ford in Kansas City and agreed to pardon him and pay him the reward in exchange for Jesse James, dead or alive. Then, on January 24, Liddil surrendered to Clay County sheriff James Timberlake as stipulated in the bargain with Crittenden that Bolton had negotiated for him. Acting on information supplied by Liddil, authorities arrested Clarence Hite in Kentucky and brought him back to Missouri. Faced with Liddil's detailed confession, he pleaded guilty to taking part in the Daviess County robbery.

While members of Jesse James's gang were turning against one another and setting in motion events that would eventually bring down their leader, Jesse himself was hiding out in Kansas City and later St.

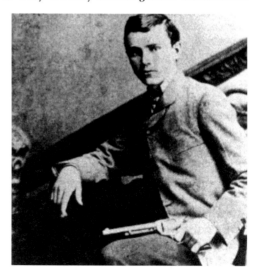

Robert Ford, who infiltrated the James gang to kill Jesse James. *Author's collection.*

Joseph. In November 1881, he, his wife, and their two kids moved into a house at the corner of Twenty-first and Lafayette Streets in St. Joseph. Jesse assumed the alias of Thomas Howard, and Charley Ford moved in with the family. On Christmas Eve, the household moved a few blocks to the Thirteenth and Lafayette location.

Near the end of December, Jesse James and Charley Ford made a trip to Ray County to get Dick Liddil. Jesse found Liddil in a sour mood, and the veteran gang member did not want to go with the other two men. Jesse suspected Liddil of plotting against him, but he made no connection between Liddil's dark mood and Wood Hite's disappearance. Returning to St. Joe, Jesse began planning a new robbery in March 1882, and he asked Charley if he knew anybody who might help them. Charley, aware of his brother's desire to collect the reward money, suggested Bob Ford.

On March 27, Jesse and Charley rode south to get Bob. They stopped for a couple of days in Clay County to visit Jesse's mother and his half brother, John Samuel, who had recently been shot and seriously wounded at a party. Then they rode on to Ray County, where they collected Bob, and the three men arrived back in St. Joseph on the morning of Saturday, April 1. They lolled around the house on Sunday, as Bob Ford awaited an opportunity to carry out his desperate scheme. Making up his mind that there was no chance to take Jesse alive, young Ford determined to kill the desperado, but Jesse, suspecting the new recruit might not be "true," kept a vigilant watch.

On Monday morning, April 3, he let down his guard. It was a warm day, and after breakfast, James took off his coat and revolvers and laid them on a bed in the front room. When he turned and took off his boots, Charley winked at Bob as a signal that this was his opportunity. Jesse mounted a chair to dust a picture frame hanging on the wall, and Bob pulled out his Colt revolver and aimed it at the back of the notorious outlaw's head. Jesse heard the click of the weapon cocking, and just as he started to turn, Bob pulled the trigger. A single shot exploded into the back of Jesse's head, exiting above the left eye and killing him instantly.

Jesse's wife, Zerelda, or "Zee" as she was usually called, hurried into the front room and saw her husband lying dead. She went to the door, saw the Ford brothers outside in the front yard, and yelled that they had killed her husband, but they denied it as they made their getaway.

After notifying authorities, though, they had now come back and not only admitted to the deed but also bragged about it and laid claim to Governor Crittenden's promised reward money. At first, Zee would not

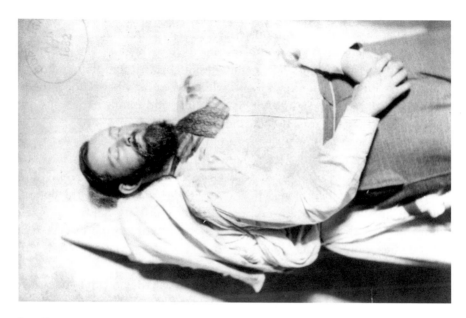

Jesse James, dead. *Courtesy of the Library of Congress.*

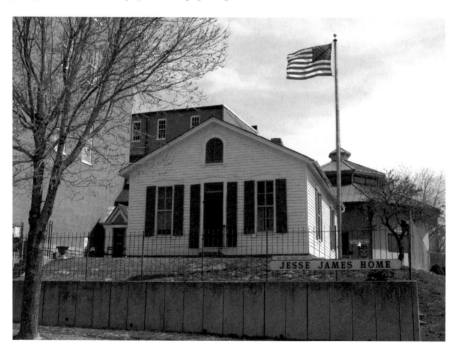

The house where Jesse James was killed, as it appears today. The house was moved from its original location to St. Joseph's east side in 1939 and moved again in 1977 to its current location a couple blocks away from its original location. *Photo by author.*

believe that "the boys" had returned, but assured that the Ford brothers were standing outside in the front yard, she went to the door and screamed at them at the top of her voice, calling them cowards and demanding to know why they had killed someone who had always befriended them. She then broke down and admitted that the dead man's name was not Howard and that she was, in fact, the wife of Jesse James.

As word spread throughout St. Joseph that the man killed was none other than the notorious Jesse James, a crowd numbering into the thousands thronged into the streets surrounding the crime scene, and later the horde trooped along as officers led the Ford boys to the county jail to await the action of a grand jury. Despite their claim and Zee's admission that the dead man was Jesse James, many in the crowd were still dubious, pointing out that false reports of the outlaw's demise had been issued before.

On the evening of April 3, Sheriff Timberlake, who had known Jesse in former years, arrived in St. Joseph, and he brought Dick Liddil with him. Both confirmed that the dead man was Jesse James. The next morning, Jesse's mother, Zerelda Samuel, arrived and, upon viewing the body at a local undertaker's office, admitted with tears in her eyes that it was her son. "Would to God it was not!" she exclaimed.

The same day, April 4, a coroner's inquest into the death at a packed Buchanan County courthouse was resumed from the previous day, and Sheriff Timberlake, Dick Liddil, Mrs. Samuel, and Mrs. James again stated that the dead man was Jesse James. Kansas City police commissioner H.H. Craig confirmed that Bob Ford was acting under instructions from him and Sheriff Timberlake, and Timberlake testified that he told Bob Ford to get Charley to help out. As she was leaving the courtroom, Mrs. Samuel saw Dick Liddil standing near the doorway and "turned on him with the ferocity of a tiger," according to the *St. Joseph Evening News*. "Traitor! Traitor! Traitor!" she shouted. "God will send vengeance on you for this." At the end of the inquest, the jury concluded that Jesse James had come to his death at the hands of Bob Ford.

Sometime during the fourth, Governor Crittenden wired the coroner requesting that the body be turned over to Sheriff Timberlake and Commissioner Craig at the conclusion of the inquest, but the coroner replied that he planned to follow the instructions of the jury and turn the body over to the family. Crittenden then agreed to such an arrangement.

The next day, April 5, curious visitors numbering into the thousands again thronged into the undertaker's place to view the dead outlaw. "The

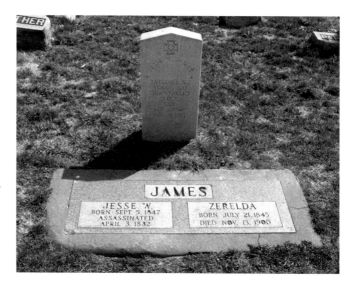

Jesse James grave at Mount Olivet Cemetery in Kearney, Missouri. James was originally buried at the James farm outside Kearney and was reinterred at Mount Olivet in 1902. *Photo by author.*

stream of eager, excited and curious humanity poured in from morning until five o'clock," said the *Evening News.*

Most people by then had accepted the fact that the dead man was Jesse James (although a few conspiracy theorists demur to this day). However, a debate continued to rage in the streets of St. Joseph and beyond concerning the way Jesse was killed. Some people defended the extreme measures employed by authorities and by the Ford brothers as necessary, considering the desperate reputation of Jesse James. Others, however, condemned the manner of the killing as cowardly and said they had more respect for the dead outlaw than they did for Bob and Charley Ford.

On the evening of the fifth, the body was turned over to Mrs. James and Mrs. Samuel, and escorted by other family members and by Commissioner Craig, they took it by wagon to the train depot and then on to Clay County, where Jesse's funeral service was held the next day at Kearney. About two thousand people flocked into town, hoping to attend the service or at least get a glimpse of the famous outlaw's body. Later the same day, Jesse was buried at the James farm about three miles outside town. (In 1902, the body was reinterred at Mount Olivet Cemetery in Kearney.)

The story of Jesse's death, however, continued to dominate newspapers in Missouri throughout April. The exploits of the James gang were recounted and romanticized, and the argument over the manner of

Jesse's killing continued to boil. Meanwhile, many eastern newspapers treated the whole story, including both the notorious feats of the James gang and Jesse's assassination, as further proof of Missouri's barbarity.

Many Missouri newspapers, including the *Howell County Journal* and the *St. Louis Post-Dispatch*, denounced Governor Crittenden for the method of the killing and even suggested that he should be tried as an accessory to murder. A few papers, like the *Sedalia Democrat*, went even further. Editor John Newman Edwards, the James brothers' chief apologist, not only condemned the method of Jesse's demise but also justified the outlaw's exploits as having resulted from his mistreatment after the war and claimed that he had never committed a single crime that was worthy of the death penalty. The Ford boys' guilty plea to first-degree murder on April 17 followed immediately by Governor Crittenden's pardon injected another element of intrigue into the controversy and revived the sensation just when it might otherwise have started to flag.

Crittenden, of course, also had his defenders among the Missouri press. For instance, the *Joplin Daily Herald*, responding to an attack on Crittenden by the *Post-Dispatch*, offered a biting satire of the St. Louis paper's publisher, Joseph Pulitzer:

> Had the rose-water scented Bohemian who vilifies the Governor through his paper been detailed to arrest Jesse James, he would no doubt have armed a posse with bouquets from the vale of Cashmere, and pressed around the fugitive until he was asphyxiated by the ravishing perfume of the offering and then carried the lamb-like form to the halls of justice on a silver platter. Pulitzer would be a daisy in the role of bandit hunter. We will wager our reputation for truth against his as a vanquisher of desperadoes, that Mr. James single and alone in his St. Joseph cottage would have routed a whole battalion of such goggle-eyed kangaroos and considered it rather insipid pastime.

Some of the Missouri papers that supported Crittenden lamented the means he had employed to rid the state of Jesse James only because they recognized that the assassination added to the romantic aura surrounding the outlaw and would no doubt immortalize him for all time. The editor of the *Richmond Conservator*, for instance, writing just days after Crittenden's pardon of the Fords, observed, "It would seem that the shooting of Jesse James continues to be the leading sensation of the day and the insane gush of the papers and their eager desire for sensation has caused them

to convert the dead train robber into the Prince of Bandits and exalt him into a grand historical character, whose deeds will be embalmed by the poets and crystallized by the historian."

The newspaperman ended his article with a plea that the "senseless gush" should stop and the "deeds and memory" of Jesse James be forgotten. Over 130 years later, however, the gush has never stopped, and the memory and deeds of Jesse James live on.

THE MOST NOTED MURDER CASE IN MCDONALD COUNTY HISTORY

The Mann-Chenoweth Affair

About 8:20 p.m. on September 12, 1883, forty-seven-year-old Dr. Albert W. Chenoweth started from Pineville in a horse-drawn buggy toward his house a half mile north of the courthouse square. He was about halfway home when two shotgun blasts exploded in the darkness in quick succession, knocking him from the buggy. The two horses trotted on, pulling the buggy pell-mell behind them until the vehicle rammed against a post near the doctor's house. The commotion drew the attention of Chenoweth's fifteen-year-old son, Charlie, who came outside and saw the horses broken loose from the empty buggy. He quickly caught one of the horses and started back toward Pineville to investigate. On the brow of the hill at the north edge of town, he found his father lying dead in the road, and he hurried into town shouting and crying that his father had been shot.

The alarm spread quickly, and a large group of men gathered at the scene. The body was removed to Dr. Chenoweth's house, where Dr. W.C. Duval helped acting coroner John Johnson conduct an inquest. Duval found that Chenoweth had been hit by eleven buckshot, all but three of which had passed completely through his body, and he extracted the remaining three.

Back at the scene of the crime the morning of the thirteenth, investigators found wadding fired from a shotgun and other evidence to indicate the assassin's hiding spot. Dr. Chenoweth was buried the same day at the Pineville Cemetery, and approximately one thousand people turned out for the funeral procession.

A former county official and state legislator, Dr. Chenoweth was a prominent citizen whose murder aroused the people to righteous anger, and they clamored

Albert Chenoweth monument in Pineville Cemetery at Pineville, Missouri. *Photo by author.*

for vengeance. Forty-five-year-old Garland Mann, who was known to have made threats against the doctor, was immediately suspected of the crime. Mann, who owned a farm on Elk River about two and a half miles below Pineville, had formerly been a saloonkeeper in Pineville, and Chenoweth, a zealous temperance advocate, had opposed him at every turn. About 1877, Chenoweth had sold Mann the building where the latter planned to set up his saloon, but then afterward, he had fought Mann's request for a liquor license. A few years later, someone had started a fire on the Pineville square, damaging a building that Chenoweth owned, and the doctor had reportedly accused Mann of the deed. To top things off, both Chenoweth and Mann were Union veterans, and Chenoweth, who was on the local pension board, had written a letter in opposition to Mann's pension application, even though Mann had been wounded at the Battle of Stones River and left with a permanent limp. Mann had made a special trip to Washington, D.C., in quest of the pension in May 1883 and had learned of Chenoweth's letter at that time.

Not only was Mann a sworn enemy of Chenoweth, but the circumstances of the crime also seemed to point to Mann as a likely suspect. On the evening of the twelfth, just a half hour or so before the doctor was killed, Mann had been seen on the square by a number of people, and he had asked one of them, when a buggy passed by, whether

the driver was Dr. Chenoweth. Then, after the doctor was killed, Mann was nowhere to be seen.

On the day Chenoweth was buried, Mann was arrested on suspicion of murder, brought to Pineville, and lodged in the county jail. Feelings ran high among the doctor's friends and acquaintances, and they talked of taking the law into their own hands.

At Mann's preliminary hearing on September 20, the throng that gathered for the occasion was in a mood of such fervent outrage that the editor of the *Neosho Times* suggested that only the lack of a clear leader among the group averted mob violence at that time. The hometown *Pineville News*, however, disputed the notion that the people behaved in anything other than an orderly manner. Spared from summary justice, Mann was bound over to await the action of a grand jury, although the *Times* editor predicted that, if the state had no better evidence than the circumstantial case presented at the preliminary hearing, the defendant would probably not be convicted of first-degree murder.

Because of the rumors of mob violence, the prisoner was moved to the Jasper County jail in Carthage for safekeeping. Mann had kept a diary for

Old McDonald County Courthouse where Garland Mann had his preliminary hearing in 1883 as it appears today. It has recently been restored as a museum. *Photo by author.*

a number of years, and he continued to do so during his incarceration at Carthage. From the time he was arrested, he had always publicly asserted his innocence, and his diary entries from early December 1883 show that he made the same declaration in private. He drew an analogy between his own case and that of Mary Surratt, whom he felt had been unjustly executed for her supposed part in the conspiracy to assassinate President Lincoln. Public opinion had formed against him during a frenzy of excitement following Dr. Chenoweth's murder just as it had against Mrs. Surratt after the president's assassination.

From his jail cell in Carthage, Mann made arrangements for his defense, mortgaging his land to hire a legal team. His attorneys assured him there was a good chance he would be released on bond on December 13. Mann said he felt confident and trusted in God that he would be. Informed on the evening of the twelfth that bond would be denied after all, he grew sad but not morose and began looking forward to being released after his formal indictment in February. He realized he might have to stay in jail even longer than that, but he vowed to "try and live in hopes." He said having to stay longer would break him financially, and his wife and kids would have a "hard time of it."

In early February 1884, Mann was brought to Pineville for his formal hearing and lodged in the jail there for the duration of the court session. During his brief stay, he and another murder suspect, Jim Wisdom, were taken out of their cells at night and hidden in the woods near Pineville on one or more occasions because McDonald County sheriff Joseph C. Seabourn had heard renewed rumors of mob violence against Mann, and Seabourn thought that Wisdom might need protection, too.

Mann was indicted for murder and retained in custody in lieu of a $10,000 bond. Although the belief that Mann was guilty was overwhelming among the citizens of Pineville, he still had friends who insisted that he receive a fair trial, and his lawyers petitioned for a change of venue because of the feeling against him in McDonald County. One was granted to neighboring Newton County for the April term.

In the meantime, Mann was taken back to the Jasper County jail for safekeeping. Jim Wisdom and John Kirby, who had killed his brother-in-law in Pineville while the February court was in session and had been immediately indicted for murder, were also taken to Carthage from Pineville at the same time.

In April, Mann was taken to Neosho, where his trial began with jury selection on the twenty-fourth. On the same day, Mann, who, of course, was

aware of the rumors of mob violence that had been circulating ever since Chenoweth's death, told his diary that, in case he died, he did not want his friends to try to retaliate because the innocent might suffer. "I know I am innocent, and events will prove so...in a short time if justice is done."

When testimony began, a long line of witnesses took the stand for the state. Several of the witnesses testified that Mann was on the Pineville square not long prior to the shooting and that he had inquired about Chenoweth. Several others, including brothers A.J. and Henry Testerman, claimed that they had heard Mann threaten to kill Chenoweth on numerous occasions. Henry Testerman added that Mann had repeatedly tried to hire him to do the job. Perhaps the most damning evidence was given by fellow jailbird Kirby, who had known Mann for ten years and had shared a cell with him at Carthage. He told the court that Mann made a jailhouse confession detailing his every move on the night of Chenoweth's murder. According to Kirby, Mann said that he got the murder weapon from A.M. Dillon's barn just off the square, ambushed Dr. Chenoweth, returned the gun to same place he got it, and struck out for home along a path that followed the river.

The defense's strategy consisted largely of trying to impeach the state's witnesses. Several defense witnesses impugned the reputation for truthfulness of the Testermans especially. A couple of them even suggested that Henry Testerman had offered his testimony for sale to the highest bidder and that he had testified against Mann only because the state had won the auction. Similarly, Kirby was accused of offering his testimony about Mann's alleged confession in exchange for leniency in his own case.

Apparently, however, Mann's lawyers had trouble finding witnesses who had not heard the defendant threaten Chenoweth at one time or another. For instance, one of the defense's rebuttal witnesses, a neighbor of the defendant named Watkins, claimed that Mann had recently told him that Chenoweth was not as bad a man as he had formerly thought, but even Watkins admitted that one day several years earlier, when Mann was drunk, he had threatened to kill Chenoweth if he ever crossed his path.

Jesse Bonebrake, who lived along the river path some considerable distance from town, testified for the defense that he heard a person, whom he believed to be Garland Mann, come along the path whistling "Yankee Doodle" within a minute or two after the sound of gunfire came from the direction of Pineville. Others who lived along the path corroborated that someone whom they thought to be Mann had come along the path about the time in question, but they could not place the time in relation to the gunfire, since they had not heard any gunfire.

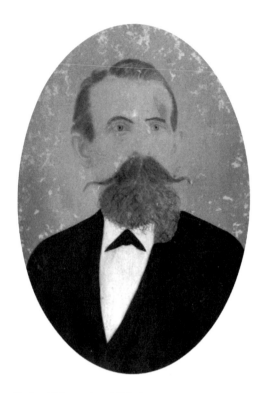

Garland Mann, circa 1882. *Courtesy of Matt Clevenger.*

Garland Mann took the stand in his own defense. He largely agreed with the state's witnesses about his movements on the evening of the murder, except he claimed that he left the public square about 7:30 p.m. and went straight home, while the state's witnesses had placed him on the square as late as 8:00 p.m. or after. He confirmed that he took the river path, and in keeping with Jesse Bonebrake's testimony, he said he was already approaching Bonebrake's place when he heard the sound of the gunshot in the distance behind him. He said he dismissed the sound as someone probably shooting fish in the river, and he continued home whistling as he went. He told the court that he checked his clock when he got there and saw that it was about 8:30 p.m. Mann also denied making the threats against Chenoweth that the various state witnesses had accused him of and denied making any confession to John Kirby.

Thirty-one-year-old Alice Mann testified in her husband's defense, corroborating that he arrived home when he said he did, except that she was more precise and gave the exact time as 8:25 p.m. This point, of course, was crucial to the defense, because if Mann arrived at his home, two and a half miles from Pineville, before 8:30 p.m., he could not possibly have fired the fatal shot, which, according to state witnesses, occurred between 8:15 and 8:30 p.m.

By early May, all the evidence had been presented, and the attorneys finished their closing arguments on the third. The case then went to the jury, and at noon on May 5, the jurors reported themselves evenly split—six for conviction and six for acquittal. A hung jury was declared, and a new trial was set for the August 1884 term.

A few new witnesses were introduced at the second trial in mid-August, but the evidence presented was substantially the same as that given at the first trial. Once again, the defense's strategy was mainly one of impeachment. Commenting on the trial a couple of days after the state had rested and the defense had begun presenting its case, the *Neosho Miner and Mechanic* observed wryly, "About half of McDonald County has been called upon to take the stand and swear that they are acquainted with the general reputation for truth and veracity of the other half of the county…and that it is bad."

The two leading members of Mann's defense team were George Hubbert and M.E. Benton (who was later a U.S. congressman and whose son Thomas Hart Benton would go on to become a famous American artist). The "grief of the state's witnesses" was due largely to the efforts of these two lawyers, according to the *Miner and Mechanic*: "After a witness is turned over to them, they go at him with sharp little steel hooks, with which they grapple into his quivering flesh, and then jerk him up, wheel him around, turn him over and over and over and over and twist him in every imaginable shape." Kirby, who had sworn to Mann's confession at the Carthage jail, was reportedly "so terribly pulled, hauled, twisted and yanked about that a doctor was called to attend him."

Despite the defense's valiant effort, the state, according to the *Miner and Mechanic*, had "made out a fearfully strong case," and on August 28, the jury came back with a guilty verdict. In pronouncing sentence, the judge allowed that the state's case was mainly circumstantial, but he felt that the evidence nonetheless supported the jury's verdict. Therefore, he told defendant Mann that he should be taken from the Neosho jail on October 17, 1884, and "hanged by the neck until dead! Dead! Dead!"

Lawyer Benton filed an appeal with the Missouri Supreme Court, and Mann's execution was stayed pending the outcome. Benton cited several reasons as the bases of the appeal. He said that the testimony of a defense witness who had heard one of the state's main witnesses make threats against Chenoweth similar to those Mann had allegedly made should not have been excluded. (The state witness who had supposedly made threats against Chenoweth was almost certainly one of the Testermans because Mann told his diary that he suspected their involvement in the murder.) Benton also claimed that Jesse Bonebrake had been unfairly attacked and contradicted by the state without the defense being allowed to rebut the attacks. The high court, however, found a more abstruse reason to overturn Mann's conviction. The court ruled in December that the presiding judge in the case had erred

in not allowing the defense to challenge prospective witnesses on the basis of their connection to law enforcement.

The case was remanded to Newton County, and Mann's third trial began on May 20, 1885. The first few days were taken up arguing various motions by the defense. One motion was to strike the case from the docket on the grounds that Mann should have been granted a change of venue to a county other than Newton, since his original request had noted the prejudice against him that existed in Newton as well as McDonald County. All of the defense's motions, however, were denied.

When the evidence phase of the trial began, the state again called a long line of witnesses to the stand. The number of defense witnesses was not as great, but according to the *Miner and Mechanic*, "it was a determined looking fighting army, apparently ready to do battle for the defendant to the last." Mann's "faithful and comely wife," along with the couple's "three little brown eyed boys," also came into court and sat beside the defendant. The court heard closing arguments the first two days of June. Then, on the morning of the fourth, a mistrial was declared when the jurors, as in the first trial, announced that they were hopelessly deadlocked.

Yet another trial was slated, and it began on August 3, 1885. The first couple of days were again devoted to the argument of defense motions, all of which the judge denied. The court then went into recess while the sheriff summoned a jury, and the trial was scheduled to reconvene on August 7.

In the wee hours of the morning on August 6, however, a mob estimated at between seventy-five and one hundred men rode into Neosho and surrounded the jail, and about ten or twelve of them dismounted. Two or three stuck shotguns through the grates of an open window and demanded that the two guards open the jail's front door, while the others started pounding on the door with sledgehammers. The jailers wouldn't open the door, but it finally flew open under the insistent pounding of the sledges. Eight or ten men trooped inside and demanded that the jailers hand over the keys to Mann's cell. When the guards again refused, some of the horde began striking the cell with the sledges, while a couple of others kept watch on the jailers. When the hammering did not produce quick results, one of the sledge wielders came back and threatened to kill the guards if they didn't give up the keys. They still refused, but about that time the cell lock yielded to the relentless pounding and the door came open.

"Damn you, we've got you now," one of the men snarled to Mann as they charged into the cell. When he resisted their attempts to drag him from the

cell, they pulled their pistols and filled him full of bullets. As the mob left, one of them issued a final warning to the jailers, threatening to give them the same treatment Mann had received if either of them ever recognized any of the vigilantes.

An inquest later the same morning revealed that Mann had been shot twice in the body and four times in the head, and any of the six shots was considered fatal. The coroner's jury concluded that the deceased "came to his death by gunshot wounds at hands of persons to the jury unknown."

In the wake of the lynching, several observers seemed to justify the action of the mob. The *Neosho Miner and Mechanic*, for instance, while condemning vigilantism in general, suggested that it was understandable in this case because of its extenuating circumstances, which the newspaper went on to cite. The overwhelming majority of people familiar with the case thought Mann was guilty. He had, in fact, been found guilty by one jury, only to have the verdict overturned on a technicality, and no one else had ever been suspected of the crime (although A.M. Dillon had been tried as an accessory for supplying the murder weapon and found not guilty). Yet the law had been powerless to mete out justice, just as it had been in a number of other murder cases in southwest Missouri in recent years. In many areas of the region, lamented the *Miner and Mechanic*, the lives of horse thieves were in greater jeopardy than the lives of murderers. "It is time for the officers of the law, for juries, as well as courts, to see to it that the penalties of murder are enforced."

Sturges's 1897 *History of McDonald County* claimed, like the *Miner and Mechanic*, that belief in Mann's guilt was almost unanimous among those familiar with the case. Such assertions, however, seem dubious in light of the fact that two of his three trials that came to a conclusion ended in hung juries, one of which was evenly split. This seeming discrepancy might be explained if some of the people who believed Mann was guilty yet felt that the state's largely circumstantial case had not removed reasonable doubt. Or else the newspaper and the county history were simply exaggerating.

The question of Mann's guilt aside, what can be said for sure about the murder of Albert Chenoweth is that it left two families devastated. Having lost their mother in 1880, the younger Chenoweth children grew up as orphans, while Alice Mann and her children were left penniless and homeless, her husband having mortgaged the family's property to finance his defense.

THE MURDER OF THE MEEKS FAMILY

The Most Horrible and Brutal Crime in the Annals of Linn or Sullivan County

About April 1, 1894, the prosecuting attorneys of Linn County and neighboring Sullivan County petitioned Missouri governor William J. Stone to release Gus Meeks from the state penitentiary in Jefferson City, where he was doing a two-year stint for grand larceny, so that he could testify against some "important criminals" with whom he had been associated in cattle stealing and other crimes in their counties. Assured that the thirty-one-year-old Meeks had been a mere "tool" under the influence of his co-conspirators, Stone signed the pardon on April 7, and Meeks was released the same day after serving only four months of his term. Unaware of the desperate character of Meeks's associates, the governor had no way of knowing he had just signed the man's death warrant.

Meeks's main partners in crime were William P. Taylor and his brother George. The thirty-two-year-old Bill was a lawyer and a bank cashier at the People's Exchange Bank of Browning, a small town in northern Linn County at the Sullivan County line. He had formerly been mayor of the town and had even served a term in the Missouri legislature. Thirty-year-old George Taylor had a farm about four miles southeast of Browning, near where the brothers had grown up. In 1891, Meeks and the Taylors had been arrested for forging a $2,000 check on the Browning Savings Bank, where Bill had worked at the time, and cashing it at Kirksville. After a change of venue from Adair County, they had been tried and convicted in Linn County Circuit Court and sentenced to five years in prison, but they had secured a new trial, which had not yet taken place. While awaiting the new trial, Bill was arrested and charged with arson for burning some buildings

in Browning in an attempt to collect insurance, to destroy property owned by Browning Savings Bank owner Beverly Bolling (who had pursued the forgery charge against Taylor), and to try to frame Bolling for the crime. Next, Bill Taylor had induced Meeks to help him forge another check. Then, in September 1893, Taylor, Meeks, and two other men were arrested for stealing cattle from a farm near Cora, a small community about halfway between Browning and Milan, the Sullivan County seat. Taylor got his case continued, but Meeks pleaded guilty at the November term of court and was sentenced to two years in the penitentiary. Before being sent to Jefferson City, Meeks, who had lived across the street from the scene of the fire in Browning, was taken to the Linn County seat at Linneus to testify against Taylor in the arson case.

However, in the spring of 1894, the arson case and the forgery cases were still awaiting final disposition in Linn County, and Taylor's trial on the cattle stealing charge in Sullivan County was docketed for the May term of circuit court. The prosecuting attorneys decided they needed Meeks to testify in order to secure convictions against Taylor. The request to have him pardoned in exchange for his testimony granted, Meeks was back home in Milan.

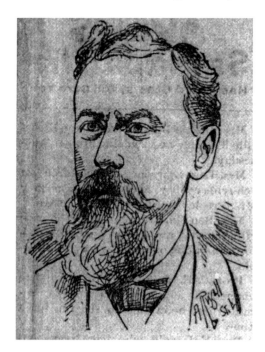

William P. Taylor sketch that appeared in newspapers shortly after the Meeks murders. *From the* Milan Standard.

On a Sunday night in mid-April, just days after Meeks arrived home, Bill and George Taylor showed up in Milan, where Meeks; his pregnant wife, Delora; and their three little daughters were staying with Gus's mother, Martha Meeks. George came to the door of the house and asked Gus to come outside where Bill was, but Gus refused George's repeated attempts to lure him outside. Finally, Bill and George came inside, and the three men had a conversation in the front room. Bill tried to talk Gus into leaving the area and not testifying against him, but Gus accused

Bill of being the cause of all his troubles and told him it would take at least $1,000 to get him to leave.

During the next couple of weeks, Bill Taylor passed the Meeks house at least a time or two, but he apparently made no attempt to come in or talk to Gus. However, during early May, he and Gus exchanged several letters, and on May 8, the two men met in Cora. Meeks agreed, perhaps at this meeting, to leave the territory and not testify against Taylor in exchange for $800 and a wagon and team. On Thursday afternoon, May 10, Meeks received a final letter from Taylor telling him, "Be ready at 10 o'clock. Everything is right."

On the night of the tenth, Bill and George Taylor drove a wagon and team, which belonged to their father, to Milan to get Meeks, arriving about 11:00 p.m. While Bill Taylor remained in the wagon, George came to the door and told Gus that everything was set. The original plan had called for Meeks to leave the territory alone and then send for his family after he got settled, but Delora mistrusted the Taylors and, thinking they would surely not harm Gus if his family were present, had insisted that she and the kids go with him. She had the family's belongings already tied in bundles, and Gus and George loaded them into the wagon. As the family got ready to leave, Gus kissed his mother goodbye, and Martha begged her son not to go, warning him that the Taylors might be laying a trap for him. Ignoring her misgivings, Gus loaded up his family, and the wagon started south toward Browning shortly before midnight.

The next morning about daylight, six-year-old Nellie Meeks came crying to the John Carter farmhouse, adjacent to the George Taylor farm, with blood and straw matted in her hair and her clothes and face bloody. She told Carter's wife, Sallie, that she spent the night in a haystack on the adjoining farm, that her little sisters were still there, and that her parents were up the road, all of them having been killed and dumped by two men. Mrs. Carter sent her nephew, ten-year-old Jimmie, over to the Taylor farm to investigate, and the boy was met by George Taylor, who was harrowing the field near the haystack. When Jimmie told his neighbor that the little girl said her sisters were in the haystack, Taylor asked what she had said about her parents, even though the parents had not been mentioned. Then, instead of looking in the haystack as Jimmie suggested, Taylor immediately drove his team to his house, taking Jimmie along with him. Jimmie stayed with the team, while Taylor went inside, until Sallie Carter, who had been watching her nephew's every move, motioned him to come home. As soon as Jimmie left, Taylor saddled up his horse and rode for Browning at a gallop.

Photo of Nellie Meeks, taken when she was about seven-years-old, not long after the rest of her family was killed. *Meeks Collection, State Historical Society of Missouri.*

On his way home, Jimmie looked under the haystack but didn't see anything unusual. When he got home, Mrs. Carter sent him and Nellie back to the haystack together after the girl volunteered to show him where to look, and they discovered the four dead bodies. Mrs. Carter then alerted the neighborhood, and several people gathered at the haystack.

The isolated location near Jenkins Hill around where the Meeks family members were killed, still looking today much as one imagines it might have looked at the time of the murders. *Photo by author.*

Gus Meeks; his wife, Delora; their four-year-old daughter, Hattie; and their eighteen-month-old daughter, Mamie, had been killed and thrown in a hole that had been dug in the field where part of the haystack had been moved aside. Some dirt had been tossed on the bodies, and the stack had then been put back in place, covering the shallow grave with about a foot and a half of straw.

Blood, a pistol, and other evidence were found at a place called Jenkins Hill about a mile and a half from the George Taylor farm on the road to Browning, indicating that the murders had been committed there. The adults and the baby had been shot, while the two older girls had been clubbed with heavy rocks. According to Nellie's later testimony, both she and Hattie had awakened after being clubbed, but Hattie had been hit again when she started crying. Realizing that the same fate awaited her if the men knew she was alive, Nellie said she "kept still and never moved" until the men were gone, and then she made her escape.

It had rained the day before, making the ground soft, and investigators found the tracks of a wagon leading from the scene of the crime through a meadow and a cornfield to the haystack where the bodies were dumped.

The tracks then led back to the road and into George Taylor's lot, where a hired hand had found and taken charge of the Taylor wagon the morning after the crime. The hired hand said he had seen George Taylor earlier that morning washing mud and clay from the wagon and team, that he had noticed blood still on the wagon when he delivered it to George's father on an adjoining farm, and that the father had tried to scrub it off. It was also noted that, because of the wet ground and the fact that his corn crop had only recently been planted, there was no logical reason that George Taylor should have been harrowing except the obvious one—to try to cover up the wagon's tracks.

Reaching Browning about 8:00 a.m., George Taylor informed his brother of the unexpected and alarming resurrection of Nellie Meeks, and the two men mounted up and started out of town to the east, "riding hard," according to a witness. At their father's farm about a half mile east of George's place, they left their horses and took to the timber on foot.

News of the murders reached Browning shortly after the Taylors had fled, and search parties began organizing to track the brothers, as word of the crimes was telegraphed to surrounding towns. Meanwhile, the bodies of the

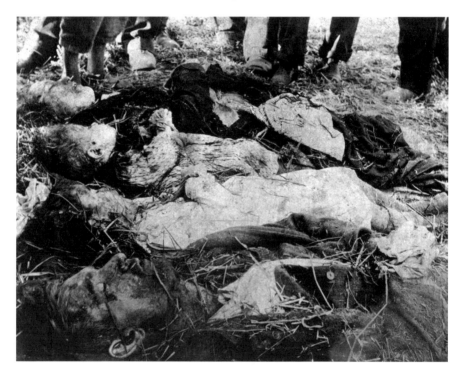

Meeks family, dead. *Meeks Collection, State Historical Society of Missouri.*

victims were hauled in a wagon to Browning, where they were placed in crude coffins with mud still on their faces.

Nellie Meeks was brought to Browning in a separate conveyance, and she told her story to area-newspaper reporters, who arrived on the scene just hours after the crimes had been discovered. Later the same afternoon, May 11, she repeated it to the coroner, who arrived from Bucklin. Nellie said that two men took her and her family away from Milan and that, as they were going up the hill, the one without whiskers (George Taylor) got out of the wagon and, while walking alongside it, shot her father. Next they shot her mother and hit her sister Hattie with a stone. Then they struck her with a stone, and she "went to sleep" and didn't know any more until she and Hattie awoke as the men were putting them in the stack of straw. After the men killed Hattie when she began to cry, the one with whiskers (Bill Taylor) kicked Nellie in the back, but she let out not a whimper. "They are all dead now," the man announced, "the damn villain sons of bitches."

The men then covered her up, and she thought she was going to suffocate because she could barely breathe. She heard one of the men complain that something would not burn, and she thought they were trying to set the straw on fire, although it was apparently a blanket they were trying to burn nearby in order to dispose of it.

After hearing Nellie's testimony and examining other evidence, the coroner's jury concluded that the members of the Meeks family had come to their deaths at the hands of William and George Taylor.

Early on Saturday, May 12, the Taylor brothers were spotted near the home of Bill's brother-in-law, not far from their father's farm, but they disappeared into the timber again and escaped.

Later the same day, the bodies of the four victims were shipped to Milan, where a local undertaker cleaned up the corpses and lined the coffins. On Sunday, May 13, the bodies were viewed by hundreds of curious spectators and then taken to the Bute Cemetery (often spelled Butte) about twelve miles southeast of Milan. A funeral service reportedly attended by thousands was held at the site, and afterward all four bodies were buried in a common grave.

Meanwhile, the fugitives made their way south through southern Missouri and finally holed up in Buffalo City, Arkansas, where Bill, whose middle name was Price, assumed the identity of William Price, and George, whose middle name was Edward, became George Edwards. On June 25, however, they were captured by Arkansas state legislator Jerry South, who recognized them from pictures he had seen in a St. Louis newspaper. They at first offered a token resistance and

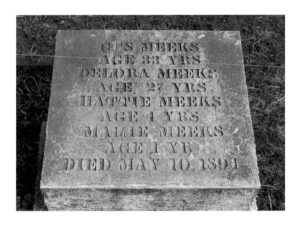

Meeks family gravestone at Bute Cemetery (aka Bunch Cemetery) in southeast Sullivan County. *Photo by author.*

denied they were wanted. Confronted with the story in the St. Louis paper, however, they admitted to their identities and became so tractable and ready to face the charges against them that South became convinced of their innocence. Nonetheless, he brought his prisoners by train back to Missouri from Little Rock in order to collect the $2,100 reward money that had been offered, $1,500 for their capture and another $600 for their conviction.

South and his captives were met in St. Louis by Linn County sheriff Ed Barton, and the party started for Linn County on June 28. A large group of men bent on vigilante justice were gathering at the Brookfield depot in anticipation of the prisoners' arrival, but Sheriff Barton, aware of the rumors of mob violence, bypassed Linn County and took the prisoners on to St. Joseph, where they were lodged in jail to await their trial at Linneus. The return of the fugitives from Arkansas had gone so smoothly that a few cynics accused South of being in cahoots with the Taylors in a scheme to share the reward money with them, but he vehemently denied the charges of collusion.

In December 1894, the Taylors were brought from St. Joseph to Linneus, where they were formally arraigned. Their lawyers immediately asked for a change of venue, and the case was moved to neighboring Carroll County, southwest of Linn. The prisoners were taken to the Carroll County jail at Carrollton to await trial.

In mid-March 1895, the Taylors went on trial at Carrollton on a charge of murder in the first degree in the death of Gus Meeks. The other charges were put on hold, since the prosecution felt proving premeditation would be easier in the case of the father. The brothers came into court well groomed and reportedly exuding an air of confidence. Train-car loads of spectators poured in from Linn and Sullivan Counties to attend the proceedings.

The state's evidence was similar to but more extensive than that presented at the coroner's inquest. The prosecution did not ask little Nellie Meeks to

testify but instead relied heavily on the testimony of Sallie Carter and her nephew Jimmie. At least two men stated that they had heard Bill Taylor threaten to kill Gus Meeks in order to "get the S.O.B. out of the way" so he couldn't testify against Taylor. Martha Meeks, who swore that the Taylor brothers had taken her family away in a wagon on the night of the murder, was also a key witness. Jerry South, who had become convinced of the Taylors' guilt since capturing them in Arkansas, testified for the state that Bill Taylor admitted during the trip back to Missouri that he and George had picked up the Meeks family in Milan on the night of the murder but that they had given Gus the money, wagon, and team as promised and left him and his family at a junction about a mile east of Browning, where the road from Milan intersected the road that ran from Browning to the George Taylor farm. In addition, several witnesses placed the Taylors on the road between Browning and Milan at the time in question.

The defense's strategy was to try to establish an alibi for the Taylor brothers. Testifying in their own defense, both Bill and George now claimed that they had been home all night on the night the murders were committed. George said that, after Jimmie Carter told him what Nellie Meeks had said, he looked under the haystack, recognized Gus Meeks's body, and went to town to get authorities but that he and Bill decided to flee because, knowing they would be suspected, they feared mob violence. Many of the defense's other witnesses were family members. Both Bill's wife, Maude, and George's wife, Della, backed up their husbands' claims to have been home on the night in question. George's mother-in-law, Argonia Gibson, confirmed her daughter's story, saying that she had spent the night at the Taylor house and that George was there. James Taylor and his wife, Caroline, both claimed that the substance on their wagon that the prosecution identified as blood was actually red paint. A few other witnesses were introduced who claimed to have seen the Taylors at or near Browning at a time when, according to the prosecution, they would have been near Milan. Two female residents of Milan swore that Martha Meeks had told them she didn't know for sure whom Gus and his family had left with on the night of the murder.

During rebuttal, the state challenged a few of the defense witnesses. A woman testified, for instance, that Argonia Gibson had told her that George was not home the night of the murder, and several witnesses were called to impugn the reputation for truthfulness of the Milan women who had tried to discredit Martha Meeks's testimony.

The defense, however, had apparently made a strong enough case to sway a few of the jurors. The evidence phase of the trial ended on April

9, and after deliberation, the jury came back and announced that it was hopelessly split, seven for conviction and five for acquittal. Many people were outraged by the verdict, because the evidence against the Taylors had seemed overwhelming. Rumors that some of the jurors had been bribed by the defense and that some of the witnesses had perjured themselves were whispered in the streets of Carrollton, and a grand jury was called to investigate the charges.

A new trial was begun in July 1895. The evidence presented was similar to what had been given at the first trial, except that, according to the *Milan Republican*, "the State furnished stronger evidence" the second time around. For instance, additional witnesses were introduced who had heard Bill Taylor make threats against Gus Meeks, and Sallie Carter and her nephew specifically rebutted George Taylor's claim to have looked under the haystack and recognized Gus's body. The defense produced a few new witnesses to try to reinforce the Taylors' alibi, but according to the *Republican*, "it was too plain that they were carefully coached." Conspicuously absent from the witness list for the defense was Maude Taylor, who had apparently changed her mind about backing up her husband's dubious story. The defense's objection was upheld when the state pointed out her absence, but Maude wasn't the only one who found Bill Taylor's story hard to swallow.

The case was given to the jury on August 2, and after deliberating only an hour and a half, it came back with a guilty verdict. The defense's motion for a new trial was denied, and the Taylor brothers were sentenced to hang on October 4. The verdict was then appealed to the Missouri Supreme Court, and the execution was postponed. In early March 1896, the verdict was upheld, and a new execution date was set for April 30.

On April 11, the Taylor brothers and a third man escaped from the Carroll County jail by breaking out of their cells, getting on top of the cells, cutting a hole in the ceiling, and climbing onto the roof. A deputy heard the commotion and managed to recapture Bill Taylor and the third man as they were using a hose to descend one side of the building. Bill shouted back up to the rooftop that they were caught and that George should give himself up, giving the impression that George was still on the roof. In fact, he was making his escape down the other side of the building, and by the time the deputy had secured the other two men in their cells, George was long gone.

Many people were outraged that Carroll County sheriff George Stanley and his deputies had let George escape, and on April 13, Bill was taken to Kansas City for safekeeping and lodged in jail there to await his execution. Search parties were organized to hunt for George, but he could not be found.

On April 28, 1896, Bill Taylor was brought back to Carrollton by train. Arriving about ten o'clock in the morning, he was escorted in a horse-drawn coach to the sheriff's house adjacent to the jail, as spectators pressed in around the conveyance, eager to get a glimpse of the infamous killer. Before he was moved to the jail, a small saw and enough strychnine to commit suicide were found on his person and confiscated.

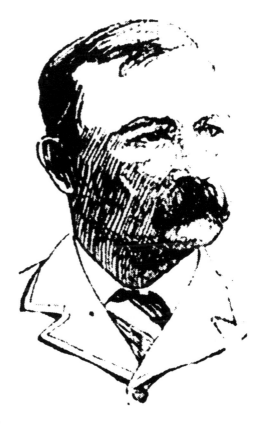

Newspaper sketch of Sheriff George Stanley, who was criticized for letting the Taylors escape but later acted as Bill Taylor's executioner. *From the* Carrollton Daily Democrat.

Taylor had never been a religious man, and up until the day before his scheduled hanging, he steadfastly maintained that he meant to die as he had lived. However, on April 29, after learning that the governor had refused to grant him a stay of execution, he had a long consultation with a priest in his jail cell at Carrollton and was baptized into the Catholic Church. On the same day, he penned a final letter in which he continued to assert his innocence.

On the morning of April 30, spectators started pouring into Carrolton to witness the execution that was scheduled for 11:00 a.m. By 7:00 a.m., an estimated one thousand people had already gathered, and the number continued to grow throughout the morning. A twenty-foot-high stockade had been built around the scaffold to keep back the crowd, but the mass of people pressed in around it with such fervor that the sheriff finally knocked it down to allow the eager hordes a clear view of the scaffold.

A few minutes before eleven, Bill Taylor began his final promenade. According to the *Carrollton Daily Democrat*, he "walked to the scaffold like a man going

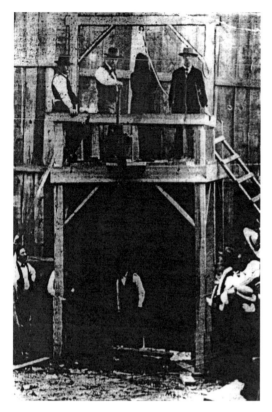

Newspaper photo of William Taylor's execution, just before he was hanged. *From the* Carrollton Daily Democrat.

on a pleasure trip, and the same stoical indifference was displayed that he has showed all through the trial." On the scaffold, the condemned man's head was covered with a mask, and Sheriff Stanley pulled the lever, dropping Taylor into eternity at exactly 10:57 a.m. He was pronounced dead thirteen minutes later, and the body was cut down four minutes after that. A funeral service was held the next day in Carrollton, and Taylor was buried at the town's Catholic cemetery.

Although dubious sightings of George Taylor were occasionally reported over the next several years, he was never recaptured. Meanwhile, Nellie Meeks became a folk hero of sorts, with numerous poems and songs composed and performed about her during the late 1800s and early 1900s. Nellie later married and lived until 1910, when she died shortly after giving birth to a baby girl, who was named Hattie, after Nellie's younger sister.

TWO ST. LOUIS LEGENDS

Stagger Lee Shot Billy and Frankie and Johnny Were Sweethearts

The killing of William "Billy" Lyons by Lee Shelton and the killing of Allen Britt by Frankie Baker took place in the late 1800s in St. Louis less than four years apart in time and less than a mile apart in distance. Scarcely reported in the St. Louis newspapers, both killings were considered obscure incidents at the time. However, what the local media failed to set down storytellers and barroom balladeers kept alive until the two stories became immortalized in song and film. "Stagger Lee" and "Frankie and Johnny" became two of the more popular songs of the twentieth century, and Frankie's story was also adapted to the big screen. Today, the legends inspired by what started out as two virtually unknown crimes are so much a part of our country's popular culture that most Americans are aware of at least fragments of the stories, and the tales are so intertwined in the collective consciousness that some people even confuse the two events.

On Christmas night 1895, Billy Lyons and Henry Crump had already had a few drinks at Henry Bridgewater's St. Louis saloon at Eleventh and Lucas Streets when they ambled a couple of blocks to William Curtis's rival saloon at 1101 Morgan, about four blocks west of the present-day Edward Jones Dome. Pausing outside the door, Lyons, according to Crump's later testimony, balked at entering the place because of the "bad niggers" that frequented it and asked Crump for a weapon with which to defend himself in case a fight broke out. Described by the *St. Louis Post-Dispatch* as one of the "worst dens in the city," Curtis's saloon was indeed considered a rough place, as was the whole neighborhood, which was known as Deep Morgan. Former St. Louis

police officer James L. Dawson, whose beat had included the Curtis saloon, remembered a few years later that the district "was by no means a desirable locality for even half decent people to live in and was the hangout of a low order of bawds, colored and white, and also many crap shooters."

Complying with Lyons's request, Crump handed his companion a knife, and the two men entered Curtis's saloon. They went to the bar toward the back of the saloon and had ordered another drink when Lee Shelton (also known as Stag Lee or Stack Lee) walked in. The thirty-year-old Shelton joined the other two men, and he and Lyons, who were acquaintances, struck up a conversation. Shelton was a carriage driver who apparently helped out on occasion at Curtis's saloon, but his real avocations were gambling and pimping. Lyons's reputation was scarcely better than Shelton's and perhaps even worse, if you believe Dawson. Speaking of the two men, the ex-cop said, "Their environment and avocation was bad indeed and their morals, if possible, were worse. The principal and only difference between the two men was in their temper and disposition to fight…Lee was not a fighter, while Lyons, when not under the influence of liquor, was very quiet indeed." However, Dawson added, when Lyons had been drinking, he was "quarrelsome and at times dangerous."

At first, according to witnesses, the two men seemed to be having a friendly conversation, but when the subject turned to politics, the discussion grew heated. At a time when many African Americans were deserting the Republican Party, feeling that it had not delivered on its promises after the Civil War, the two men were on opposite sides of the political spectrum. In addition to his other activities, Lee Shelton was an organizer for the Democratic Party, and Curtis's saloon was apparently a hotbed of Democratic sentiment. Lyons, on the other hand, was a brother-in-law of Henry Bridgewater, who was a strong Republican and a man of considerable influence in the black community. It is easy to see, therefore, why Lyons might have considered Curtis's saloon enemy territory and been leery about entering the place.

As the argument between the two men escalated, Shelton and Lyons started striking each other's hats. Shelton grabbed Lyons's derby and knocked it out of shape, and Billy told Shelton to pay him seventy-five cents for the damage. Shelton promised to pay, but when he didn't immediately fork over the six bits, Lyons grabbed Lee's Stetson. Shelton demanded it back, but Lyons refused. Shelton pulled out a .44 Smith and Wesson revolver and conked Lyons on the head with it, threatening to kill Billy if he didn't hand over the hat. Still unwilling to give up the hat, Lyons reached into his pocket for the knife Crump had given him and started toward Shelton, cursing him and saying, "I'm going to make you kill me." After a brief scuffle, Shelton fired a shot that struck Lyons

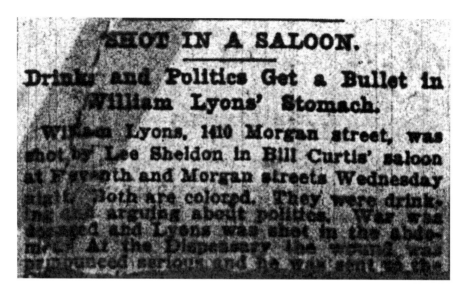

SHOT IN A SALOON.

Drinks and Politics Get a Bullet in William Lyons' Stomach.

William Lyons, 1410 Morgan street, was shot by Lee Sheldon in Bill Curtis' saloon at Seventh and Morgan streets Wednesday night. Both are colored. They were drinking and arguing about politics. War was declared and Lyons was shot in the abdomen. At the Dispensary the wound was pronounced serious and he was sent to the

Brief article in the *St. Louis Post-Dispatch* reporting Lee Shelton's shooting of Billy Lyons on Christmas night 1895.

The building where Lee Shelton lived at the time he killed Billy Lyons, as it appeared in 2008. Shelton also reportedly ran a "lid club" or whorehouse in the building. *Courtesy of Jeff Kopp.*

in the abdomen, and he collapsed, mortally wounded. Shelton retrieved his hat, put it back on his head, and walked calmly out of the saloon.

Shelton was tracked to a nearby rooming house, where he sometimes stayed, and was arrested for the shooting at about 3:00 a.m. on December 26. Meanwhile, Lyons was taken to a dispensary and then on to City Hospital, where he died about an hour after Shelton's arrest.

A coroner's jury, heavily attended by what one newspaper called "the Henry Bridgewater faction," was held on December 27. The next day Shelton was charged with first-degree murder, but he was released on bond about two weeks later. His first trial in July 1896 ended in a hung jury, but he was retried at the May 1897 term of the St. Louis Circuit Court and found guilty of second-degree murder. In early July, he was sentenced to twenty-five years in the state penitentiary. When he was checked in at the Jefferson City facility on October 7, he was described as a mulatto standing five feet, seven and a half inches tall and weighing 114 pounds, and under the heading of "Habits" was listed "intemperance."

Prison life did little to reform Lee Shelton. On March 9, 1899, he received five lashes for "loafing on the yard." Three months later, he got eight stripes for shooting craps. On July 16, 1902, he was given ten lashes for stealing from the kitchen, and in September 1905, he was put in solitary confinement for being out of his cell at night and crap shooting. Despite his infractions inside the penitentiary, his Democratic friends on the outside began lobbying for his release as early as 1899. A number of them suggested that the only reason he had been convicted to begin with was because of the active role Henry Bridgewater had taken in the prosecution and that Shelton had, in fact, been railroaded. The prisoner was finally pardoned by Governor Herbert Hadley in October 1909 and released the following month. Less than two years later, however, he was sent back to Jefferson City on a robbery charge, and he died of tuberculosis in the penitentiary hospital on March 11, 1912.

By that time, the legend of Stagger Lee, or Staggolee, was already well established. Field chants, songs, and folktales about Stagger Lee sprang up almost immediately after the St. Louis shooting and were kept alive in African American culture by word of mouth. The earliest written lyrics about Stagger Lee date to 1903, and the first recording occurred in 1923. Hundreds of musicians, from Fats Domino to Bob Dylan, have since recorded versions of the song. Perhaps the best-known version, by rhythm and blues singer Lloyd Price, reached number one on Billboard's Hot 100 in early 1959 and sold over a million copies. The details of Stagger Lee's story change from one version of the song to another, and the song has been embraced by white audiences and

even performed by white singers. However, the portrayal of Stagger Lee as a "bad man" who is not to be messed with is the central theme in all versions of the song, and the symbol and legend of Stagger Lee continue to resonate, especially in the culture of black males. As Cecil Brown, author of a book entitled *Stagolee Shot Billy*, has suggested, Stagger Lee is more than a historical figure or a mere song. Stagger Lee is, according to Brown, a "metaphor that structures the life of black males from childhood through maturity."

> *Stagger Lee shot Billy*
> *Oh, he shot that poor boy so bad*
> *Till the bullet came through Billy*
> *And broke the bartender's glass.*
> <div align="right">"Stagger Lee"</div>
> <div align="right">Lloyd Price</div>

In the fall of 1899, twenty-two-year-old prostitute Frankie Baker was living at 212 Targee Street, about twelve blocks southwest of the bar where Stagger Lee had killed Billy four years earlier. Targee was located in Chestnut Valley, a district that had perhaps an even worse reputation than Deep Morgan. Albert (aka Allen) Britt, a talented seventeen-year-old ragtime pianist and Frankie's part-time pimp, lived with her off and on. Described by a neighbor as "a beautiful, light brown girl who liked to make money and spend it," Frankie supported Albert and often lavished him with gifts.

On the night of October 14, Frankie went to the Phoenix Hotel, where Albert was supposed to be playing for a cakewalk (a type of walk or slow dance popular in the African American community around the turn of the twentieth century in which a cake was offered as a prize to the couple with the most precise or creative steps), and she caught him in a hallway of the hotel making love to eighteen-year-old sporting girl Alice Pryor (aka Nellie Bly). Albert and Alice had reportedly danced together and won a prize earlier in the evening. Frankie called Albert outside and asked him to come back to their apartment, but they ended up getting into a heated argument on the street outside the building.

Frankie went back to her rooms alone, and Albert didn't show up until several hours later in the early morning of the fifteenth. He admitted he had been with Alice Pryor all night, and the argument was renewed, with Albert

Frankie Baker, as a young woman. *Courtesy of* St. Louis Post Dispatch.

picking up a lamp at one point as if to throw it at Frankie. When Albert threatened to leave Frankie for good, she started crying and headed out the door to find Alice Pryor. Albert then pulled out a knife and told her he'd kill her if she took another step. Retreating back into the room, Frankie reached under a pillow on her bed, pulled out an H&R .38-caliber pistol, and shot Albert in the abdomen.

Britt was taken to City Hospital in grave condition. Frankie was picked up by police and taken to the hospital so that Albert could positively identify her as the person who shot him, but she was not formally arrested until he died during the wee hours of October 19, four days after the shooting. Despite a coroner's finding that Frankie had acted in self-defense, she was charged with murder. At her trial in November, however, the jury apparently agreed with the coroner's inquest and on Friday the thirteenth returned a verdict of not guilty by reason of justifiable homicide, an eventuality that later caused Frankie to declare, "I ain't superstitious no more."

By the time of Frankie's acquittal, a song about her killing of Albert Britt was already being sung in the bars of St. Louis. In fact, within days after the shooting, even before Britt had died, according to some sources, a local barroom bard named Bill Dooley was singing a ballad he had composed called "Frankie Killed Allen."

Frankie Baker herself said she first heard the song about two months after she shot Britt. According to her story, people began singing it whenever they would see her on the street. After about a year, she left town in humiliation and went to Omaha. However, the song had reached Nebraska ahead of her, and feeling haunted by it, she moved on to Portland, Oregon. There she continued to lead the life of a "sport" for another twenty years or so, but she finally put away her fancy clothes and jewelry about 1925 and led a respectable life working in a shoeshine parlor and later as a chambermaid.

Meanwhile, the legend of Frankie and Allen continued to grow. The song soon became known as "Frankie and Albert" and eventually evolved into "Frankie and Johnny." The first published version of the song appeared in 1904, and other versions soon followed. Mississippi John Hurt made one of the first recordings of the song in 1928 and entitled it "Frankie and Albert." It has since been recorded over 250 times, usually as "Frankie and Johnny," and its performers have included Lena Horne, Sam Cooke, Elvis Presley, Johnny Cash, and Stevie Wonder.

Frankie's story also made it onto the stage and the silver screen. In 1930, actor and director John Huston wrote and produced a play entitled *Frankie and Johnnie*. Borrowing from the "Frankie and Johnny" theme, Paramount Pictures released *She Done Him Wrong* in 1933, and the film's star, Mae West, sang the "Frankie and Johnny" ballad in the movie. Frankie Baker sued Mae West and Paramount Pictures but lost in the courts. In 1936, Republic Pictures released *Frankie and Johnny*, starring Helen Morgan, and in 1942 Frankie Baker again sued.

Hoping to collect up to $200,000, she returned to St. Louis in February 1942 to testify in the case, and she accompanied reporters to a vacant lot behind the old Municipal Auditorium to show them where the shooting had taken place. (The rooming house in which Frankie had lived had been torn down years earlier.) Over the years, scholars had disagreed about the origin of the "Frankie and Johnny" ballad, and some had traced it as far back as the case of Frankie Silver, who was executed in North Carolina in 1833 for having killed her husband with an axe. Thus, lawyers for Republic Pictures produced supposedly expert witnesses to testify that the ballad of "Frankie and Johnny" had been around long before Frankie Baker killed Albert Britt, and the all-white jury found in favor of the moviemaker. Frankie went back to Portland and died there in a mental institution in 1952. Her memory lives on, however, because today there is almost universal agreement that the legend of Frankie and Johnny on which the popular song is based originated with Frankie Baker's shooting of Albert Britt in St. Louis in 1899.

Frankie drew back her kimono
pulled out her lil .44
root a toot toot three times she shot
right through the hardwood door
She shot her man cause he was doin her wrong.
 "Frankie and Johnny"
 as performed by Elvis Presley

YOU'VE KILLED PAPA AND NOW YOU'RE KILLING MAMA

The Most Brutal Murder Ever in Cape Girardeau County

About 6:00 a.m. on the morning of July 1, 1898, as Bernice Lail and her sixteen-year-old daughter, Jessie, finished milking the cows on the Lail farm about three miles south of Jackson, Missouri, Bernice's husband, James, joined them, and the three started together toward the springhouse, where the two women planned to store the milk. As they passed the barn, James Lail turned into the open bay of the building, commenting that he had about forty things to do, while his wife and daughter continued toward the springhouse. When the two women approached a gate leading out of the barn lot to the springhouse, they noticed John Headrick, a nineteen-year-old young man from the neighborhood who had formerly worked on the Lail farm, enter the barn lot through another gate and head toward the barn. Nothing in his appearance aroused suspicion, however, and they carried the milk through the gate and down a slope to the springhouse. They had just gotten inside the springhouse when they heard the sound of gunfire come from the barn.

Dashing back up the hill, they saw James Lail running from the barn and John Headrick firing a pistol at him as he gave chase. Lail collapsed near the fence and then looked back and pleaded with Headrick to please not shoot him anymore.

Bernice Lail scrambled over the fence, threw herself atop her husband's body, and started crying as Headrick stood reloading his pistol. Unmoved by her tears, he shot Mrs. Lail through the back and shot Mr. Lail several more times. The villain then beat Lail with the pistol after he was already dead

and gave Mrs. Lail a lick or two as well. He started to shoot Mrs. Lail again, but Jessie arrived in time to knock the gun away so that the shot went astray. "John Headrick," she screamed, "what do you mean? You've killed Papa, and now you're killing Mama." Jessie temporarily wrenched the gun from Headrick's hand, but he wrested it back and shoved her away, telling her he didn't want to kill her but he would if she didn't back off.

According to Jessie's later testimony, Headrick then started marching her at gunpoint toward the house, but when they reached the gate, they turned and saw Bernice get up and run down a lane toward the adjoining farm of her mother-in-law, Marzilla Lail. Jessie tried to hold Headrick back and hollered, after he broke loose, to warn her mother that he was coming, but he caught up with Mrs. Lail nonetheless. He knocked her down and stabbed her with a knife. He then slashed her arm in two places, sliced one of her ears almost off, cut her throat, and left her for dead as she weltered on the ground. Jessie had waited until she saw that her mother was not going to escape before she came running, and by the time she got close to the scene, Headrick had already started back toward the house. He turned her around and again marched her toward the house past her father's dead body.

When they were near the house, they turned and once again saw Bernice Lail get up and start running toward Marzilla Lail's house. Seeing that the forty-three-year-old Bernice was out of reach, Headrick remarked, "By God, the old woman is gone. You can't kill her, can you?"

Inside the house, he made Jessie pour him some water so that he could wash his hands. At one point, she asked him why he had done what he did. "By God, people can't run me down," is all he would say.

Another time, Headrick asked Jessie whether she was going to swear against him, and when she replied that she was, he threatened to kill her. When he got ready to leave, he told her to pour some water into a bottle that sat on a table, but she was too nervous to pour it; so Headrick poured it himself, saying he was going to take it with him to mix morphine in and kill himself. Threatening again to kill Jessie if she tried to follow him or raise an alarm until after he was gone, he then set off on foot toward Jackson.

As soon as Headrick was gone, word of the murder spread quickly, and parties of men scoured the neighborhood looking for him during the rest of that day and all of the next. On the night of July 2, he sent word that he would surrender if given assurances that he would be protected from mob action, and he was arrested late that night at the home of a neighbor, Milton Gholson. To avert possible vigilantism, Sheriff J.H. Jenkins immediately

took the prisoner to Cape Girardeau and then, by rail, on to St. Louis, where Headrick was held pending legal action.

Meanwhile, a coroner's jury concluded that James Lail came to his death from five gunshots, all fired by the hands of John Headrick. James Lail's funeral service was held at the Jackson Baptist Church a day or two after his murder. Bernice Lail's wounds were at first thought fatal, but after doctors operated on her on July 5 to remove the bullet from her body, they decided she would recover.

Headrick was brought back to Jackson from St. Louis on August 12 and indicted a few days later for first-degree murder. He was then returned to St. Louis for safekeeping, and his trial was set for a special session of the Cape Girardeau County Circuit Court to be held in November.

The prisoner was again brought back from St. Louis on November 14. The judge overruled a defense motion for a change of venue, and the evidence phase of the trial began before a packed court on the eighteenth. The state presented the facts of the case largely as they have been given here thus far and suggested that Headrick's dismissal from his job as Lail's hired

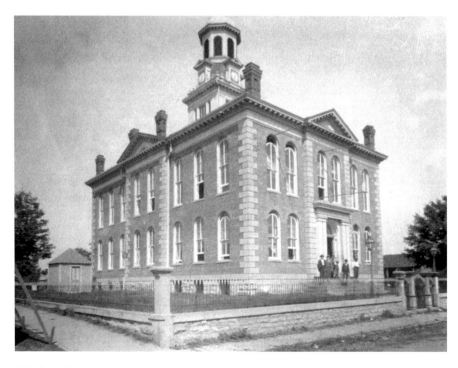

Old Cape Girardeau County Courthouse, where Headrick was tried. *Courtesy Cape Girardeau County Archive Center.*

hand was the primary motive for the crime. The defense, on the other hand, sought to show that a romantic relationship had existed between Jessie Lail and their client and seemed to suggest that she might have even aided and abetted him in the murder. Jessie adamantly denied these accusations on cross-examination.

The state and the defense agreed that John Headrick had come to work for James Lail about three and a half months before Lail's murder, but the circumstances attending his employment were a matter of dispute. According to Headrick's testimony at the trial and his statement after all legal proceedings had been concluded, he first met Jessie at a neighborhood dance in late January or early February 1898, and the two hit it off right away. Jessie supposedly "took [him] by the arm and led [him] upstairs" that very evening. A week or so later, Jessie was at a store in Jackson with her mother and sent word to Headrick by a mutual acquaintance, seventeen-year-old Albert Summers, to come to the store and see her if her mother was not around. When Headrick showed up, however, he saw Bernice and went on without talking to Jessie. Another week or so later, Headrick got a letter from Jessie asking him to come to work for her father. She said she and Albert had told her dad that Headrick wanted to work for him and that her dad had agreed. If Headrick came to work for her father, Jessie said, they would have one good time. Headrick wrote back agreeing to come to work on the Lail farm, and Mr. Lail went to young Headrick's home and left word with his parents that he had a job for their son.

Headrick gave up the job he already had and went to work at Lail's farm in early to mid-March. According to him, he and Jessie were sneaking around seeing each other from the very beginning. In fact, they "were the same as a married couple" when Jessie's parents weren't around.

Headrick's idyllic world, if it existed as he claimed, soon came crashing down. On the evening of June 12, 1898, he and another young man (possibly Albert Summers) appropriated a horse and buggy on the Jackson square and took the rig for a joy ride. Headrick was located at the Lail farm a day or so later, and James Lail cooperated with the constable in the arrest of his farmhand. Although Headrick was held only a brief time on a misdemeanor charge, Lail hired another young man, John Broderick, to take his place, and when Headrick showed back up at the Lail farm on or about June 15, Lail informed him that he had no work for him. According to Headrick, Lail also told him to leave and not come back because he didn't want him around his daughter.

Lail paid Headrick $1.10 of the $2.10 he had coming for work he had done before his arrest, and Headrick named a place in Jackson where Lail

could leave the other dollar when he got the money. Although Headrick didn't quarrel with Lail over being discharged, he issued an ominous warning as soon as Lail left the room, saying, in the presence of Jessie and Albert, that the next thing he did they would remember the rest of their lives. Young Summers wondered whether the threat might be more than idle bluster because he knew Headrick was carrying a pistol, and what happened a few minutes later hardly alleviated his concern. After Headrick retrieved his clothes from the room where he had been staying and the two young men started walking away from the farm together, Headrick showed Summers a bottle of morphine and said he was going to kill himself if he didn't get work soon.

Even if Headrick's romantic relationship with Jessie was more than a figment of his imagination, Jessie apparently never took it as seriously as he did, because somewhere along the line she started seeing another young man from the neighborhood, twenty-two-year-old William Kirksey. After Headrick was discharged from his job at the Lail farm, he mostly loafed around Jackson, a mile or two from his parents' farm, and reportedly tried on at least two occasions to talk other young men into helping him break up the budding romance between Jessie Lail and William Kirksey.

According to Headrick, about a week after he was discharged by James Lail, he received a letter from Jessie asking him to meet her, but he made no attempt to see her at that time. A few days later, however, on Saturday, June 25, he saw her in Jackson, and she again asked him to meet her at her house. Jessie denied that such a meeting occurred, but testimony from disinterested parties confirmed that Headrick and Jessie had seen each other very briefly in Jackson on the day in question. The witnesses said, however, that Headrick had merely approached a buggy that Jessie and another young woman were in and had said a word or two to Jessie as the buggy started off.

On Wednesday evening, June 29, according to Headrick, he went to the Lail farm to meet Jessie and hid out for the next two nights and one day. During that time, he and Jessie met secretly several times, including once during the wee hours of July 1, only about three hours prior to James Lail's murder, and he claimed that she brought him food. However, Jessie, who had married William Kirksey prior to the trial, told the court that she did not know Headrick had been hanging around the farm until he told her so after the murder and that he also told her he had not had anything to eat.

Headrick said that, on the morning of the murder, after he saw Jessie and her parents start toward the springhouse, he sneaked into the barn with plans to hide out in the hayloft as Jessie had previously told him to do. When he saw

that James Lail had turned into the barn, he hid instead in the corncrib, but the door on the crib, which was about three feet off the ground, creaked when he closed it, giving his location away. Lail opened the door and said, "You damn sonofabitch, what are you doing here—monkeying with Jessie again?"

Headrick told the much larger Lail, who was standing at the door blocking his exit, to let him out, but Lail refused and hollered for Bernice to bring his gun. Headrick tried to leave, but Lail struck at him with a currycomb. When Headrick jumped back, Lail struck at him again, and Headrick pulled out his pistol and fired. From this point, the stories of the prosecution and the defense essentially agreed, as Headrick did not deny that he shot Lail multiple times, even continuing to shoot and beat him after he had fallen. Nor did he deny shooting and cutting Mrs. Lail.

The jurors in the case apparently gave more credence to Jessie and her mother's version of events than they did to Headrick's story, or else they decided that whether Headrick and Jessie had been sweethearts had little bearing on the case, because on November 26, 1898, they returned a verdict of guilty after deliberating only about an hour. The judge sentenced Headrick to hang on January 4, 1899, but in early December, Headrick's lawyers appealed the case to the Missouri Supreme Court.

The main grounds for the appeal were that Headrick's motion for a change of venue should not have been denied. However, Headrick had submitted only his own statement of the prejudice against him in applying for the change of venue, whereas state law called for two supporting affidavits from other citizens. The appeal was, therefore, overruled and the verdict confirmed.

Headrick's new execution date was set for June 15, 1899. Shortly after 6:00 a.m. on the appointed morning, Headrick, according to the *Cape Girardeau Democrat*, walked "with a steady, firm step and without the twitching of a single nerve" from the jail to the gallows, which stood inside an enclosure beside the courthouse at Jackson. Headrick, who had joined the Methodist Church a week earlier, was accompanied by his spiritual advisors, two physicians, the prosecuting attorney of the county, and the sheriff, who was also the executioner. Only these men and a few other citizens were allowed inside the enclosure, but a large crowd gathered outside the enclosure.

When Headrick mounted the scaffold, said the *Democrat*, he "was as nervy as any man who ever walked up the steps to the gallows." Although the people outside the enclosure could see only the condemned man's head, he could see them, and when asked whether he had any final words, he scanned the crowd and gave a brief statement declaring that there was someone else

who was guiltier than he was of the crime for which he was ready to pay the penalty. The trap was sprung at exactly 6:18 a.m., but the fall did not break Headrick's neck. He hung for fourteen minutes before he died from strangulation and was then left to hang another thirteen minutes before his body was cut down.

On June 13, two days before his execution, Headrick had written a full confession in his jail cell that he requested not be made public until after his death. The *Cape Girardeau Democrat* refused to print it on the grounds that it was libelous, but the *Jackson Missouri Cash Book* published it in full. Headrick's story about the events leading up to the day of the murder was similar to what he had said at his trial, except that he cast Jessie as even more of a femme fatale than he had previously. He said that when he worked on the Lail farm, he could get no rest because Jessie was always "after him." She would sometimes come to his room and stay most of the night, and she wanted to drink whiskey and smoke cigarettes with him every chance they got.

He claimed, too, that Jessie played a much more active role in the murder of her father and attempted murder of her mother than he had previously said. On the morning of the crime, according to Headrick, Jessie actually met him in the barn after the milking chore was complete, and her father caught them together in the corncrib and threatened to kill both of them. Headrick then shot Lail, just as he testified at his trial, and shot him one more time as Lail was fleeing the barn. Jessie followed as Headrick chased her father, and after Lail had fallen and Bernice Lail had flung herself across his body, Jessie said, "John, give me that gun and I will finish them both." She took the pistol and shot her father several more times and her mother once. After emptying the gun on her parents, she began hitting them with it and struck her mother so hard that a piece of the handle broke off. She then took out a knife and started stabbing and cutting her mother. Headrick said that he and Jessie then parted as lovers, kissing and promising not to give each other away, and that the whole story about his forcing Jessie to march to the house and pour him a pan of water was nothing but a made-up lie.

Second guessing the verdict of a jury from the perspective of 115 years after the fact is problematic at best, and considering that Headrick admitted to firing at James Lail a second time after Lail was running away, the guilty verdict against him was not entirely unjust, regardless of whether his story about Jessie was true. However, it does seem possible, if not probable, that at least a grain of his story might have been true and that Jessie was not as innocent in the matter as she and her mother testified at the trial. Bernice Lail was near death at the time of the coroner's inquiry into her husband's

murder, and by the time of Headrick's trial, she might have decided that she didn't want Jessie to die or spend the rest of her life in jail, regardless of what the girl might have done. And Headrick, still under Jessie's spell, might have confessed to a greater role in the murder than he actually had in order to shield the young woman who had been his sweetheart.

DOWN FOR THE COUNT

The Murder of Middleweight Champ Stanley Ketchel

On Monday, October 10, 1910, wealthy Springfield businessman Rollin "R.P." Dickerson hired a young couple who introduced themselves as Walter and Goldie Hurtz to work on his ranch in eastern Webster County as hired hand and housekeeper. He had previously made arrangements for his friend Stanley Ketchel, world middleweight boxing champion, to manage the property in order to gain experience before taking over a ranch of his own that he had recently purchased. On Wednesday, October 12, Dickerson, Ketchel, and the young couple boarded a train in Springfield bound for the ranch. Sitting in separate cars from Dickerson and Ketchel, the Hurtzes were not introduced to the young pugilistic champion until they disembarked at the Conway station a few miles north of the ranch and Dickerson told them that Ketchel would manage the ranch and be their immediate boss. It proved to be a fateful meeting that would soon cost one of the three young people his life and the other two their freedom.

Walter and Goldie had passed themselves off to Dickerson as a married couple, but the truth was they were neither married nor named Hurtz. Walter's real name was Dipley, and Goldie's actual name was Goldie Smith. The twenty-three-year-old Dipley and his twenty-two-year-old girlfriend had grown up together in the Chadwick area of Christian County, but until a month prior, they had not seen each other in almost ten years. Dipley's family had moved to Jasper County about 1902, and Goldie had gotten married to a man named Knight in April of that year, when she was just thirteen years old, and soon had a child. She had divorced and remarried

just a year or so later, but the second marriage was also short-lived. Around 1905, she had married a third time to a man named Osborne, but the couple had soon separated. About the time of the separation, Knight had successfully sued for custody of his and Goldie's child. Goldie, as she later admitted, had a "bad reputation," but she claimed she was never immoral until the court took her child away. Meanwhile, Walter had worked a little in the mines around Webb City and tried his hand at barbering before joining the navy in February 1908. He deserted in the summer of 1909 because his superior officers, as he later claimed, treated him with insolence and disrespect. After his desertion, he fled to Arizona and stayed there a while.

During the summer of 1910, Goldie had been living in Kansas, and in September, she made a trip back to Missouri to visit her mother and stepfather. On her way to Christian County, she stopped at Webb City to renew her acquaintance with Walter, and he decided to go to Christian County, too, to see his sister. The couple met up again a few days later at the Chadwick train station and rode in the same hack to the old neighborhood. Goldie agreed to stop with Walter at his sister's house under the agreement that he would take her on to her stepfather's house the next day. On the drive to the sister's place, Walter proposed that, as a joke, they introduce themselves as husband and wife when they arrived. After introducing themselves to Walter's sister as man and wife, the couple took a walk to the barn, where Walter proposed that they get married for real. Goldie balked because of her checkered past, but Walter said he had made mistakes in his life, too, and they should let bygones be bygones. Goldie said she couldn't marry him because she wasn't sure her divorce from Osborne was final, but they agreed to marry as soon as they found out for sure. In the meantime, they continued passing themselves off as a married couple. After spending several days in Christian County, Walter and Goldie traveled to Springfield, arriving on October 7, and checked into a rooming house on Boonville Street under the assumed name of Hurtz. On the tenth, Walter went to an employment agency looking for work and was referred to Dickerson.

Born in Grand Rapids, Michigan, twenty-four-year-old Stanley Ketchel was king of the middleweight boxing world in 1910, having gained the undisputed title in 1908. Nicknamed the Michigan Assassin, he had stepped up in weight class in 1909 to defeat light heavyweight champion Jack O'Brien, and despite being outweighed by at least twenty-five pounds, he had also given heavyweight champ Jack Johnson a hard fight, all the time regularly defending the championship in his own weight division. After losing to Johnson, Ketchel immediately began campaigning for a

rematch, and during the early months of 1910, he fought several matches in his own class.

Ketchel's frequent fights and his hard living, however, had begun to wear him down, and in early September, Dickerson, who had grown up with Ketchel's mother in Michigan, invited him to come to Missouri. Still hoping for a rematch with Johnson, Ketchel accepted the offer with plans to train and regain his strength. After arriving in Springfield on September 14, he found that he liked the area so well that he decided to retire from boxing and stay on in the Ozarks. He joined the local Elks Lodge and quickly became a popular figure in Springfield. He bought a ranch, and while waiting to close on the transaction, accepted Dickerson's offer to run his place temporarily.

After Dickerson's party arrived at the Conway station from Springfield on Wednesday, October 12, R.P. rented a carriage and took Ketchel and

Springfield businessman R.P. Dickerson, at right, arranged for his friend Stanley Ketchel, world middleweight boxing champion, to work on his Webster County ranch in 1910. *Courtesy Ozarks Watch.*

When "The Man" Was a Boy

Many of you are aware that recently I purchased a number of items from a relative of Stanley Ketchel. Four items I was able to acquire were photos the family had of the great middleweight. Two of these were taken in Butte, where Ketchel got his start and show Stanley at the age of no more than 15 years. These have not been previously seen. When I sent them to expert Bill Schutte, Bill said, "No doubt about it, its the Man when he was a boy!"

The other two show Ketchel as champ and these photos have been seen before but rarely. I thought you might like to see them.

There is an interesting twist. The photo at lower left and the two from Butte were all taken by "J.R. O'Connor" but the later picture was from his studio in San Francisco. O'Connor was Ketchel's manager in the early years. No one I talked to was aware O'Connor was a photographer. All photos are mounted studio shots.

A montage of photos of world middleweight champion Stanley Ketchel. *From Boxing Collectors News.*

the young hired couple to his ranch seven miles to the south. Ketchel took a room in the main house while Walter and Goldie were temporarily lodged in a smaller house nearby until C.E. Bailey, whose place Ketchel was taking as ranch foreman, could remove his things from the main house. Thursday morning, Dickerson returned to Springfield.

On Friday afternoon, October 14, while Walter was working in a wheat field, Ketchel helped Goldie move the couple's belongings from the smaller house to the main house. About five o'clock, as they were finishing the chore, Ketchel told Goldie, according to her later testimony, that he was soon going to have some lady visitors for whom he wanted her to cook, and Goldie asked whether they were related to him. He said one of them was a distant relative and the other one was his sweetheart. Standing near the doorway of the main house, he then asked Goldie whether she would like to be his sweetheart, as he began to force himself on her. He shoved her inside the house and assaulted her, throwing her on the bed and "partly accomplishing his purpose." Afterward, he threatened her and Walter's life if she told on him.

Nevertheless, Goldie told Walter that evening that Ketchel had threatened them and that they needed to leave the ranch. Later, Dipley went to a second small house on the ranch, where sharecropper Luther Brazeale and his family lived and where Bailey was spending the night prior to leaving the next day. Calling Bailey outside, Dipley announced that he was quitting because he thought he and Ketchel might have trouble, and he wanted to know whether he and Goldie could ride to the railroad station with Bailey the next morning. Bailey said they could. That night, Goldie, pressed by Walter about exactly what had happened, finally told him that Ketchel had attacked her earlier that day.

Walter and Goldie ate breakfast at the main house early Saturday morning, and then Walter went outside to smoke. Ketchel came into the dining room, where the bed in which Walter and Goldie had slept the night before was located, and sat at the dining table. Goldie had started serving him breakfast when Walter reappeared at the kitchen door behind Ketchel between 6:30 and 7:00 a.m. According to Walter and Goldie's story, Ketchel looked over his shoulder, asked Walter what the hell he was doing still around the house at that time of day, and told him he should be out in the field working. Walter said he wasn't going to the field today because he was quitting. When Ketchel asked him what was the matter, Walter swore, "You're not so damned innocent that you don't know why I'm here."

Ketchel then opened his shirt revealing a pistol and told Walter that if he started anything, he would "shoot him in two pieces." Walter stepped past Ketchel, picked up a .22 rifle leaning against the foot of his and Goldie's bed near the dining room wall, and sprang back into the kitchen doorway as Ketchel stood and placed his hand on the pistol. When Walter told him to throw up his hands, the prizefighter, looking over his shoulder, retorted, "By God, I won't," and Walter promptly shot him in the back, the bullet entering the right shoulder and ranging into the right lung.

Ketchel stumbled through a doorway into his room and fell to the floor. Walter went outside and then came back in and picked up Ketchel's .45 revolver off the floor. He and Goldie hurried outside and saw Bailey and Brazeale returning from a pasture. Bailey called to Walter to ask what the trouble was, and Walter hollered, "I shot the S.O.B."

Bailey went into the main house to check on Ketchel, who had managed to make it to his bed and was lying down. Bailey called a doctor and then called R.P. Dickerson. Returning to Brazeale's house, he gave Walter the name of a local constable and told him to contact the officer, but instead Walter fled, leaving Goldie at Brazeale's house.

As soon as he received Bailey's call, a frantic Dickerson hired a special train at Springfield, and he soon sped to the ranch with two doctors, a Springfield policeman, two bloodhounds, and two newspapermen, arriving about 11:45 a.m. Dickerson rushed to Ketchel's side, and Ketchel told him that Hurtz had shot him in the back while he was sitting at the table and that the woman had robbed him after he was shot. Dickerson announced to the crowd who had gathered at the ranch that he was offering a $5,000 reward for Hurtz. After the doctors operated on Ketchel at the scene, he was loaded in a wagon and driven to the Conway station, where Dickerson renewed his reward offer. Ketchel was rushed on to Springfield, but he died that evening, shortly after arrival. Goldie was brought to Springfield on Saturday evening and guarded at the rooming house on Boonville Street where she and Walter had stayed earlier in the week on the chance that Walter would try to meet her there. When he didn't show up, she was placed in jail. She admitted that her real name was Goldie Smith and that Walter's last name was Dipley, not Hurtz.

Meanwhile, the Springfield policeman and his bloodhounds joined Webster County sheriff C.B. Shields and a posse of citizens in a search for the fugitive. However, Dipley was captured without incident the next morning at the home of Thomas Hoggard near Niangua, where he had stopped to spend the night, saying he was passing through the area in search of some stray horses. The captive was brought to Springfield and placed in a separate cell of the same jail where Goldie was lodged.

A funeral service for Ketchel was held in Springfield on Sunday, October 16, at the Elks clubhouse with an estimated ten thousand people in attendance. The next day, the body, accompanied by R.P. Dickerson, was shipped to Michigan for burial.

On Tuesday, October 18, a coroner's inquest held in Springfield concluded that Ketchel had been shot by Walter Dipley and that Goldie Smith had aided him in commission of the crime. Later the same week, the two were taken to Marshfield for their preliminary hearing and formally indicted in Webster County Circuit Court.

At their trial in January 1911, the prosecution's theory of the crime was that Dipley and Smith had conspired to kill Ketchel in order to rob him of several hundred dollars that he was thought to have had on his person at the time, that Goldie had purposely seated Ketchel with his back to the kitchen door so Dipley could shoot him in the back, and that they were both, therefore, guilty of first-degree murder. State witnesses testified that Ketchel, while lying in bed after being shot, remarked, "I guess they have got me," and the prosecution, attempting to prove Goldie's involvement in

Stanley Ketchel's death certificate. *Missouri State Archives.*

the crime, placed great emphasis on the fact that he used the word "they." Springfield attorney Roscoe Patterson, whom R.P. Dickerson had hired as a special prosecutor to spearhead the state's case, also spent considerable time attacking the character of the defendants. He cited Goldie's three failed marriages and the immoral life she had led for several years, and he assailed Dipley for deserting from the navy and for taking up with Goldie. Seeking to undercut Dipley's claim that he had grabbed the rifle only after he and Ketchel exchanged heated words on the morning of the shooting, the state put ranch hand G.A. Johnson on the stand to testify that he had seen Dipley with the rifle early that morning just before the shooting.

Led by Springfield attorney T.J. Delaney, the defense sought to show that Ketchel had, in fact, assaulted Goldie Smith. Many observers thought Dipley's lawyers would claim he acted out of rage and try to get a reduced verdict, but instead, they argued self-defense, aiming for an acquittal. They

maintained that Goldie had no part whatsoever in the shooting and that Walter, already leery of Ketchel because of his supposed threats, only acted when the prizefighter reached for his pistol. They also tried to shift some of the focus of the trial onto R.J. Dickerson and his seemingly obsessive quest for vengeance against the killers of Stanley Ketchel, hinting at scandal by suggesting that he was, in fact, Ketchel's illegitimate father.

After testimony and closing arguments, the judge instructed the jury that if they believed Dipley had provoked the fatal incident in any way, they could not find that he acted in self-defense. Even if they believed Ketchel had assaulted Goldie Smith, that fact did not constitute grounds for a verdict of self-defense.

Apparently, the jury not only did not believe Dipley had acted in self-defense but also gave little credence to Goldie's story. In a decision that surprised many observers, who thought Goldie would be acquitted or get off with a light sentence, the jury rendered a verdict on January 25 of guilty of murder in the first degree for both defendants, and both were sentenced to life imprisonment.

The defense immediately filed a motion for a new trial. When it was overruled, Delaney appealed to the Missouri Supreme Court. The prisoners, however, were taken to the penitentiary at Jefferson City, and their writs of habeas corpus requesting to be released or returned to Webster County pending the outcome of the appeal were denied.

When the high court finally considered the appeal at its April 1912 term, Dipley's conviction was upheld, but Goldie Smith's was overturned. The Supreme Court held that the state's theory that Goldie had prearranged to have Ketchel seated at the table was "the merest conjecture" and that absolutely no evidence had been introduced to support it. The only testimony suggesting her involvement was Ketchel's use of the word "they" when he said, "I guess they have got me." Ketchel's use of the plural, however, could logically be interpreted to mean simply that he was aware that Goldie had probably told her "husband" about the previous day's assault. The Supreme Court ruled that the judge in the case should have directed a verdict of not guilty. Goldie was released on May 10, 1912, and she later returned to Springfield, where she ran a café and married a gambler named "Gentleman Jim" Hooper.

In 1912, R.P. Dickerson had a $5,000 monument erected at Ketchel's grave in the Polish Catholic Cemetery in Grand Rapids. The same year, Thomas Hoggard, his brother, and a neighbor—the three men who had captured Dipley at Hoggard's farm near Niangua—sued to collect the

$5,000 reward R.P. Dickerson had offered for Dipley. Dickerson had refused to pay because he said he offered the reward only if Dipley were killed, not if he were captured alive. After the three men won a verdict directing payment of the reward, Dickerson appealed to the Greene County Court of Appeals, but the verdict was upheld in May 1914.

Meanwhile, Walter Dipley did not immediately take to life behind bars. Listed as "intemperate" when he was admitted to the state pen in 1911, he got in trouble in 1915 for having saws, daggers, and dope in his cell. However, by 1934, his behavior had improved enough to win a parole, and he was released on May 19 of that year. He went back to the Webb City area, worked in the mines a while, and then got a job working for a shoe manufacturer in Carthage. On August 10, 1940, he was pardoned by Missouri governor Lloyd Stark, and he had his citizenship restored.

Chapter Ten

A DIRTY MIXUP ALL TOGETHER

The Notorious Welton Murder Case

Forty-six-year-old Frank Welton was working on his farm near Teresita, Missouri, in southwestern Shannon County in May 1918 when he looked up and saw forty-two-year-old Carrie Hofland, no doubt the last person he wanted to see, approaching. He hurried out to meet her and tried to talk her into leaving, explaining that he had a young woman living with him, but Carrie hadn't come all the way from Nebraska for nothing. She had been trying to locate Frank ever since he had run off and left her a year earlier, and she had gotten off the train at Mountain View, four miles away, and walked all the way out here. She wasn't about to just turn around and go back.

She let Frank talk her into introducing her as his sister, and the two walked to the house to meet Pearl, who at twenty-three was just half Frank's age. Frank told Carrie at first that Pearl was just staying with him temporarily until she could reunite with her family in Kentucky, but he soon admitted that they were legally married. Carrie also might have noticed that Pearl was several months pregnant. However, she went along with the charade for a couple of days, pretending to neighbors as well as to Pearl that Frank and she were brother and sister, until she tired of the sham and went back to Nebraska in humiliation.

Frank Welton and Carrie Hofland were not brother and sister at all. They were, in fact, common-law husband and wife. Carrie went by the surname "Welton," and they had lived together for thirteen years. Carrie's daughter considered Frank her stepfather, and the family's neighbors around O'Neil, Nebraska, thought Frank and Carrie were a legitimately married couple.

That is, until Frank up and decided he wanted to take off in the spring of 1917. The two had divided their assets, with Carrie getting the farm they were living on and Frank getting most of the personal property. Frank had exchanged the property for cash and left, telling Carrie he was going to southern Missouri to look for land. According to Carrie, he also told her he would send for her after he got settled. Arriving in southwest Missouri, he had hooked up with the J.T. Tyler family, including Tyler's daughter Pearl, and brought them with him to a forty-acre farm he purchased near Teresita. Frank ended up marrying Pearl in September 1917, while the rest of the Tyler family moved to Kentucky.

After returning to Nebraska in May 1918, Carrie apparently ruminated on her rejection and decided she was not going to give up without a fight. In mid-January 1919, she reappeared at the Welton farm and resumed the charade she had begun several months earlier, pretending once again to be Frank's sister. Frank told her she couldn't stay, but Pearl suggested she be allowed to stay at least long enough to rest up. On Friday, January 17, a couple of days after her arrival, Frank left the house after lunch to do some work in a patch of timber, and Pearl, suspecting there was more to the relationship between Frank and Carrie than sibling affection, asked Carrie whether she was Frank's wife.

When Carrie replied that she was, according to her own later story, Pearl "pitched into [her] and knocked [her] down" and tried to kill or hurt her. During the ensuing struggle, Carrie, who stood five feet, two inches and weighed 120 pounds, overpowered the smaller Pearl, who had given birth to a baby girl since Carrie's last visit and was weak and thin from nursing the baby. Carrie got a grip around Pearl's neck and didn't let go until she had strangled the petite, 95-pound Pearl to death. She then dragged the body to a nearby cistern, or well, and dropped it into the shallow water of the sixteen-foot-deep pit. According to her story, Carrie then went back and picked up the crying baby to try to comfort it and, while leaning over the cistern to make sure Pearl was dead, accidentally dropped the infant in.

Frank emerged from the timber about that time, and Carrie went running toward him to tell him that Pearl and the baby were in the cistern. She told Frank that she had earlier seen Pearl standing by the well holding the baby, and after going for a walk, she had returned to find both of them down in it, with Pearl apparently having jumped into it in an attempt to kill both herself and the baby. Frank secured a rope and quickly shinnied down into the cistern. He tied the rope around the baby, and Carrie drew the infant up. She then tossed the rope back to

Frank, who tied it around Pearl. He then clambered back up the side of the cistern and pulled Pearl out.

Carrie took the baby into the house, and Frank carried Pearl. Mother and baby were laid down and dry garments put on or draped over them. Pearl showed no signs of life, but the baby, who had landed atop its mother and not been completely submerged in the shallow water, began to revive.

Frank ran to the nearby Stockman farm to give an alarm, but by the time the Stockmans arrived, Pearl was obviously dead. Mrs. Stockman grew suspicious of Frank and Carrie's story that Pearl had drowned, partly because there was no water in the victim's lungs. The neighbors suggested that authorities should be notified, and Frank agreed to initiate an investigation. A doctor was summoned from Mountain View, and he officially pronounced Pearl dead. He shared the Stockmans' skepticism of Frank and Carrie's story and suggested that Shannon County authorities should be notified since the death had occurred in that county, while Mountain View was in Howell County.

The next day, Saturday, January 18, a coroner's inquest was held, and the jury found that Pearl had not drowned but rather been choked to death. It

PEARL WELTON MURDERED!

The 23 Year Old Wife of Frank Welton, of Near Teresita, Victim of Jealousy of Carrie Erickson Hofland of O'Neil Nebr.

STRANGLES VICTIM WITH BARE HANDS

Then Drags Body to the Cistern and Throws in Head First. While Holding Murdered Woman's Baby Over Cistern and Gloating Over Victim, Gets Nervous and Drops Child On Mother.

A newspaper headline from the *Mountain View Standard* tells the story of Pearl Welton's murder.

also noted a mark on her temple that seemed to have been caused by a blow from a blunt instrument, which might have stunned the victim but was not hard enough to crack her skull. In addition, they found several bruises on her arms. Carrie had already confessed to one or more of the neighbors by this point that she alone had killed Pearl, but apparently the jury was skeptical of that story as well as the drowning story. It concluded, instead, that Pearl Welton came to her death at the hands of Frank Welton and Carrie Hofland, and both suspects were arrested. Frank, however, was allowed to attend Pearl's funeral under guard on Sunday, January 19. After the service at the Welton farm, Pearl's remains were taken to Mountain View for burial.

A preliminary hearing for the accused killers was scheduled at Teresita on January 21 at the home of Justice of the Peace John House. Shannon County assistant prosecuting attorney Warren M. Barr was present, and prior to the official hearing, Carrie sought a private interview with him, saying she wanted to talk to him about "this transaction." Barr warned her that he represented the state and that she needed to be careful about making any statements that could be used against her, but she said she didn't care. She said that she alone had killed Pearl and that she didn't even care whether she had a trial, and she gave the same confession to House during the official hearing. Commenting in the wake of the preliminary hearing, a local newspaper called the entire case a "dirty mixup all-together."

Frank was released after the preliminary hearing, while Carrie was taken to the county seat at Eminence and held at the home of Sheriff John T. Bay awaiting trial for first-degree murder at a special term of the Shannon County Circuit Court slated for January 27. When Howell County judge E.P. Dorris arrived on that date from West Plains to hear the case, not only had Carrie changed her mind about not having a trial, but she had also hired a lawyer, who requested and was granted a continuance. Carrie's trial was reset for later in the year, and she was transferred to the Howell County jail at West Plains to await the proceeding. The jail at Eminence was deemed too unsanitary for female prisoners, and there had also been rumors in Shannon County of possible vigilante action.

At the time Frank Welton was released after Carrie's confession at the preliminary hearing in January, there was a good deal of sympathy for him in the neighborhood where the crime had occurred. However, that sentiment soon began to change. Many of the neighbors began to suspect that Carrie might have confessed to shield Frank, and in late April, they circulated a petition asking that a grand jury be convened to consider whether there was enough evidence to indict Welton as an accomplice

to Pearl's murder. About the same time, J.T. Tyler, Pearl's father, brought bigamy charges against Frank. Welton was arrested on the bigamy charge but released on $1,000 bond.

Carrie's trial began at Eminence on June 2. She took the stand in her own defense and admitted, as she had previously, that she and Pearl got into a struggle when she told Pearl that she was married to Frank. From that point on, however, her testimony differed from what she had said before. She said she tried to get away but supposed she must have got hold of Pearl and hurt her. She claimed to have no recollection of exactly what happened, however, and said she did not know whether she put Pearl in the cistern or not.

Carrie's daughter, twenty-one-year-old Myrtle Hofland, traveled from Fremont, Nebraska, to testify on her mother's behalf. Myrtle told the court that her mother and father had divorced in Iowa when she was only about six years old and that her mother and Frank Welton had met in South Dakota not long afterward and started living together. The family had later moved to Nebraska and lived there for several years. Myrtle's tearful testimony about her mother's devotion to Welton and his mistreatment of her was credited by some observers with eliciting sympathy for Carrie.

At any rate, after the evidentiary phase of the trial ended on the evening of June 4, the jury came back the next morning with a verdict of guilty of murder in the second degree, not first degree, and gave Carrie a sentence of ten years in the state penitentiary. She arrived and was processed in at Jefferson City on June 8.

The grand jury requested by Welton's neighbors to investigate his role in Pearl's death had convened on June 2, the day before Carrie's trial began, but the jurors had recessed until her trial was over, waiting to see if she would implicate him on the stand. However, despite Carrie's vague recollection of other details and despite the prosecution's promises to go easier on her if she would testify against Frank, she had continued to insist that he had no part in the murder. Still, many observers felt sure that she was shielding Welton, and on June 5, after Carrie's sentencing, the grand jury indicted Frank for first-degree murder, even though she had been convicted of second-degree murder and he had initially been suspected only of being her accomplice. His trial was set for the September term of the Shannon County Circuit Court, but he requested and was granted a change of venue to neighboring Carter County.

Frank's trial was held at Van Buren during the October term of the Carter County Circuit Court, and Carrie, as the state's main witness, was brought from Jefferson City to testify in the case. Taking the stand, she revised her

original testimony even more than she had at her own trial, now claiming that she did not kill Pearl during their struggle but instead escaped and fled to the barn after Pearl knocked her down. Later, as she emerged from the barn, she saw Frank standing by the cistern and saw that Pearl and the baby were down in it. Frank then got them out of the cistern with her help, and she and Frank took them into the house. The trial ended on October 31, and the jurors, after deliberating all night, came back the next morning and announced that they were split, eight for acquittal and four for conviction. A mistrial was declared and a new trial scheduled for the following year.

Frank's second trial began on April 26, 1920, in Van Buren, and Carrie once again was escorted from the state prison to testify. Her story was the same as it had been at Frank's first trial except that she now claimed that the baby was never in the cistern. This refinement, of course, tended to reinforce the argument she set forth at Frank's first trial that he was the one who killed Pearl because otherwise the jury would have had to believe that he also intended to kill his own infant daughter. Frank, on the other hand, never wavered from his original story that he came back from cutting wood in the timber and was met by Carrie, who told him Pearl and the baby had drowned.

The evidence phase of the trial ended on April 29, and the jury, after being out just a short time, found Frank guilty, like Carrie, of murder in the second degree, but his sentence was upgraded to fifteen years in the state pen. Welton's lawyers immediately filed a motion for a new trial, but it was denied on May 4. They then appealed the case to the Missouri Supreme Court, and Frank was released on $10,000 bond pending the outcome of the appeal.

In early December 1920, the high court overturned the verdict, and Frank Welton went free. In issuing their ruling, the justices observed that the only evidence against Welton was the testimony of Carrie Hofland and that her testimony had changed so much and been so thoroughly impeached as to be worthless. On the other hand, Welton's story had been consistent, and his actions on the day of the crime suggested his innocence. Neighbors who arrived shortly after the crime saw the abrasions on his hands caused by the rope when he had scrambled into the cistern to retrieve Pearl and the baby. In order to believe Carrie's testimony, the high court said, one would have to believe that Frank killed or mortally wounded Pearl and put her in the cistern and then immediately tried to rescue her. In addition, Frank had hurried to a neighbor's house to give an alarm, and he had readily agreed to instigate an investigation on the suggestion of a neighbor. Also, contrary to Carrie's latest testimony, there was evidence that the baby had, in fact, been

in the cistern. The high court said that the only explanation it could fathom for the unjustified verdict was that the jury must have convicted Welton on the grounds of his perceived moral failing rather than objectively weighing the evidence.

In the wake of the Supreme Court ruling, a Van Buren newspaper observed that the high court's decision and Frank's release represented the "last chapter in the notorious Welton murder case," but the final chapter actually unfolded about sixteen months later. On April 22, 1922, Carrie Welton (aka Hofland) was paroled from prison by Missouri governor Arthur M. Hyde after serving less than three years of her ten-year sentence. Whether she and Frank ever saw each other again is unknown.

THE KANSAS CITY MASSACRE

An Arena of Horror

Shortly after dawn on the morning of June 16, 1933, gangsters Charles "Pretty Boy" Floyd and Adam Richetti headed north out of Springfield, Missouri, along U.S. Highway 13 in a 1933 Pontiac Coupe that they had stolen in Oklahoma a week earlier. The twenty-nine-year-old Floyd had a history of serious crime dating to 1925, and his twenty-four-year-old partner had a record going back five years. However, the desperate duo, according to later reports, were on their way to Kansas City merely to visit their girlfriends.

A few miles north of Springfield, the Pontiac broke down, and an old man towed them into Bolivar, where Richetti had once lived. They went to the Bitzer Chevrolet garage, where Richetti's brother, Joe, was a mechanic, to get the car worked on. As the mechanics went to work on the disabled vehicle, several people, including proprietor E.V. Bitzer, gathered around to look at the new Pontiac. Presently, Polk County sheriff Jack Killingsworth, who had previously worked at Bitzer's as a car salesman, stopped by for a morning visit and joined the gathering crowd. Overhearing Floyd comment to Bitzer that the car would do eighty-five miles an hour, Killingsworth, motioning to a dented fender, interjected that it looked as if it had done eighty-five once too often.

Richetti, who recognized the lawman, grew alarmed by the chance remark and reached into the back seat of the vehicle for a machine gun. Richetti ordered the bystanders to line up against the wall and was about ready to shoot the sheriff when Joe Richetti intervened, telling his brother that Killingsworth, who was not even armed, was only there for a visit and not on official business. Floyd convinced Richetti to put the machine gun back in the car, but the bystanders were ordered to stay put, while the mechanics continued working.

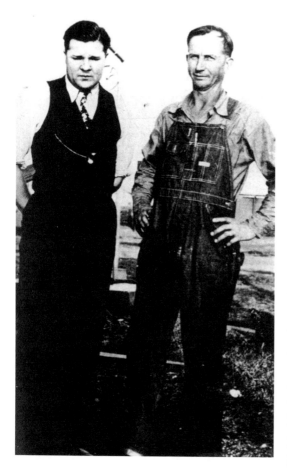

Charles "Pretty Boy" Floyd with his ex-wife's uncle in Oklahoma, early 1933. *Courtesy of the FBI.*

Customer Claude Blue then drove into the shop and told the mechanics he wanted a lube job. When he got out of his car and headed back outside, Killingsworth started to join him. Richetti again grabbed the machine gun and ordered both men to halt. Killingsworth did, but Blue darted out the door and across the street to a drugstore, where he called Springfield police and a Polk County deputy. Another person at the store called a Springfield radio station, which promptly informed its listeners of the hostage crisis.

Meanwhile, Floyd took charge of the situation in the garage. Covering the hostages with an automatic pistol, he told Richetti to put away the machine gun and to find them a getaway car. On the street in front of the building, Richetti commandeered his brother's 1933 Chevy and had it filled with gas by the unsuspecting attendant in the front part of the business. He then drove to the garage at the rear and transferred his machine gun, some ammunition, and other supplies from the Pontiac to the new vehicle. Floyd forced Killingsworth into the back seat of the vehicle and then slid in beside him, and the Chevy sped away with Richetti at the wheel.

Still aiming for Kansas City, the fugitives headed north, with Killingsworth guiding them along the back roads and law officers in close pursuit. At one point, a highway patrol car got within firing distance of the fugitive vehicle, but Killingsworth, prodded by a gun stuck in his side, waved it back.

Formerly Bitzer's Garage, this is the building where Sheriff Jack Killingsworth was kidnapped as it appears today. *Photo by author.*

Near Deepwater, the outlaws decided to switch vehicles. Flagging down motorist Walter Griffith, they ditched the Chevy and piled into Griffith's Pontiac. They then resumed their flight, taking Griffith along for the ride. They made their way to the vicinity of Olathe, Kansas, where they rested in a secluded area for about three hours. After dark, they got back in the car and drove about an hour or two before Floyd stopped about ten o'clock at a building in Kansas City to make a phone call. Soon afterward, he and Richetti released their hostages at Ninth and Hickory Streets near the downtown area. After letting the captives out of the car, the gangsters drove it a short distance, abandoned it, and got into a waiting vehicle, which sped away. Griffith and Killingsworth walked to where the Pontiac had been abandoned, got in, and drove toward home. At Lee's Summit, they stopped to phone their families and then continued to Griffith's hometown of Clinton.

Meanwhile, events were transpiring four hundred miles away at Hot Springs, Arkansas, that would soon form a fateful junction with those happening in Kansas City. Hot Springs was a noted resort for the criminal underworld, and in June 1933, two FBI agents, Joe Lackey and Frank Smith, had learned that Frank "Jelly" Nash, an infamous bank robber and gangster, was hiding out

Newspaper photo of Sheriff Jack Killingsworth a few days after he was kidnapped by Pretty Boy Floyd and Adam Richetti. *From the* Bolivar Herald.

there. The forty-six-year-old Nash, who had served three separate prison stints, had escaped from the federal penitentiary at Leavenworth in 1930 and was suspected of helping seven other prisoners escape from the same place the following year. On June 16, Lackey and Smith, accompanied by McAlester, Oklahoma police chief Otto Reed, went to Hot Springs and arrested Nash around noon, about the same time that Floyd and Richetti were ditching their Chevy near Deepwater.

The law officers drove Nash to Fort Smith, and that night, they boarded a Missouri Pacific train bound for Kansas City. However, word of Nash's capture quickly spread among his confederates back in Hot Springs, and the phones of underworld figures from Chicago to Kansas City to Joplin, Missouri, started ringing. One of the men notified of Nash's capture was Kansas City gangster Verne Miller, a close friend of Nash. Despite the law officers' efforts to keep their itinerary secret, their travel plans quickly leaked out, and Miller promised Nash's wife he would try to do something to free Nash before they got him back to Leavenworth. Miller called his associates in New York and Chicago and even called the Barkers in St. Paul, but it was too short notice. Late on the night of the sixteenth, Miller turned to the Kansas City mob. Crime boss Johnny Lazia told Miller he didn't want local talent involved in the scheme, but according to FBI records, he mentioned that Floyd and Richetti had just hit town. (Some modern historians deny the FBI's claim that Floyd and Richetti were involved in the Kansas City shootout.) Miller went to the house of ill repute where Floyd and Richetti had been driven shortly after getting to Kansas City, and he hired them to help carry out his desperate design. He took them to his house to spend the night, and

early the next morning, they drove to Union Station in his 1933 Chevrolet Coupe and took up strategic positions outside the depot.

The train from Fort Smith rolled into Union Station about 7:15 a.m. Lackey, Smith, and Reed escorted Nash off the train and were met on the platform by Kansas City FBI agents Reed E. Vetterli and Raymond J. Caffrey and Kansas City policemen W.J. Grooms and Frank Hermanson. Entering the station, the seven law officers walked through the lobby in a fan formation with their handcuffed prisoner in the middle. Reed packed both a pistol and a shotgun, Lackey carried a shotgun, and the other five officers had pistols. The entourage exited through the east door and crossed the plaza to a parking area, where Caffrey's unmarked 1932 Chevrolet sat. The Caffrey vehicle had been designated to carry the whole group, except for Grooms and Hermanson, on to Leavenworth, while the two Kansas City policeman would follow in another car. Unknown to any of the eight men, three assassins with machine guns lurked not more than twenty-five feet from Caffrey's two-door Chevy.

When the agent unlocked his car, Nash started to climb in the backseat, where prisoners usually rode, but Caffrey told him to get in the front. Lackey, Smith, and Reed got in the back, with Smith in the middle. Meanwhile, Nash sat momentarily behind the steering wheel waiting for the folding front middle seat, which had been lowered to allow the officers easier access to the backseat, to be raised back up. Caffrey stood outside the driver's door waiting to take the wheel as soon as Nash slid over, Vetterli stood on the passenger's side of the car toward the rear, and the two policemen were near the passenger's front.

A man carrying a machine gun (thought to be Floyd) suddenly stepped out from behind a lamppost near the front passenger's side of the Chevy and shouted, "Put 'em up, up, up!" Miller and Richetti stepped out from behind a nearby car at about the same time carrying a sawed-off shotgun and a second machine gun. Grooms drew his pistol and fired two shots, wounding Floyd in the shoulder. Miller yelled, "Let 'em have it!" and the plaza outside the Union Station was quickly transformed into what the *Kansas City Star* later that day called "an arena of horror." Floyd started blazing away with his machine gun, and Grooms and Hermanson fell to the pavement riddled with bullets. They lay motionless on their backs with their straw hats lying some distance from them, having, according to the *Star*, been "blown...away like a strong wind" by the gunfire.

Meanwhile, Miller and Richetti opened up on the lawmen's vehicle, puncturing it full of holes and shattering the windows. Caffrey returned

fire, but he soon fell mortally wounded from a shotgun blast and sprawled near the driver's side door. The men inside the car were, in Agent Vetterli's words, "powerless before the red fire from the machine gun." Sitting in the middle of the back seat, Agent Smith tried to draw his pistol but, realizing immediately that he was outgunned, ducked down and played dead while bullets splintered the car. Sitting to his left, Chief Reed sagged down on top of him dead. Sitting to his right, Agent Lackey slumped down with three bullets to the back and pelvis and started groaning, seriously injured but alive. Shortly after the firing began, Smith glanced up and saw that Nash's toupee had fallen off and his head was partially blown away.

After receiving a flesh wound in the initial burst of fire, Vetterli dropped to the pavement beside the Chevy and took cover. According to his initial story, he waited until the firing was over and then raised up and shot at the getaway car as the gangsters were leaving, but other reports suggest that he instead immediately dashed toward the depot through a hail of bullets to call for reinforcements.

When the firing died down, Miller and Floyd walked over to Caffrey's bullet-riddled vehicle, and Floyd looked inside to check on Nash. "He's dead," he said. "They're all dead." The fact that Nash was sitting in the front seat and Agent Smith was sitting in the middle of the back seat, where a prisoner would normally have been expected to ride, might partially account for why Nash was killed and Smith was not.

As the gunmen raced toward Miller's automobile, motorcycle cop Mike Fanning charged out of the depot and fired three shots. One of the gangsters, thought to be Floyd, dropped to the ground but got back up and piled into Miller's '33 Chevy with the other two desperadoes, and the three gunmen sped away to the west with Miller at the wheel. Fanning claimed he saw four men in the getaway vehicle, which is just one example of the mountain of contradictory evidence that would be accumulated over the next weeks and months in the case.

Back at Union Station, the scene was still chaos. Over one hundred shots had been fired in about ninety seconds, and not only was Caffrey's car riddled with bullets, but also the depot itself had been hit by numerous stray shots. During the shooting, terrified bystanders had run screaming in every direction, and cars had rammed into one another as their drivers tried desperately to escape. Now as the initial shock died down, curious onlookers began gathering to gawk at the horrific scene.

Smith climbed out of the riddled vehicle unscathed. Caffrey and Lackey were rushed to the hospital, but Caffrey died shortly after arrival.

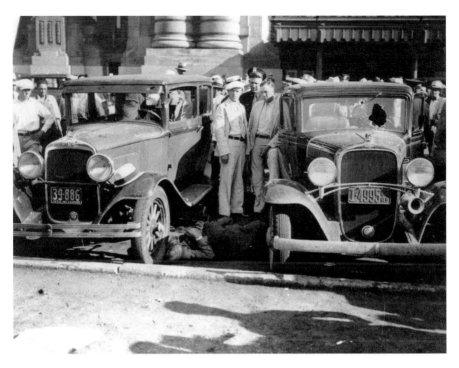

The scene outside Kansas City's Union Station shortly after the massacre. Note the bodies lying between the two cars. *Courtesy Kansas City Public Library, Missouri Valley Special Collections.*

Union Station, as it appears today. *Photo by author.*

Lackey survived but soon left the FBI. Vetterli was treated for his minor wound and released

The Kansas City Massacre left the American public outraged and provided an impetus for the FBI's growth into a powerful federal law enforcement agency. In the aftermath of the heinous Kansas City crime, there was general agreement that Verne Miller had been the ringleader in carrying it out, but how many other gunmen were involved and their identities were a matter of much debate, even in the days immediately following the event. Gangsters Harvey Bailey and Wilbur Underhill were among those mentioned as possible participants in the deadly encounter. Sheriff Killingsworth was one of those who doubted that Floyd and Richetti had been involved, and their guilt was not universally accepted even among federal agents. FBI director J.

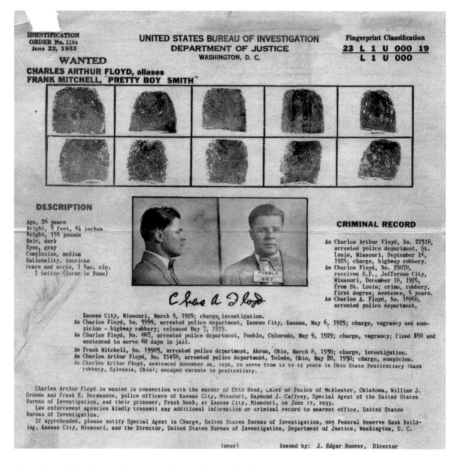

Pretty Boy Floyd wanted poster. *Courtesy Wikipedia Commons.*

Edgar Hoover, however, wasted little time in naming Pretty Boy Floyd and Adam Richetti as prime suspects in the crime, and an arrest warrant was officially issued in July, a month after the incident. Among the most damning evidence uncovered against the pair was a fingerprint left by Richetti on a beer bottle in Miller's house.

After the massacre, the gangsters reportedly fled back to Miller's house, where Miller arranged for medical attention for the injured Floyd and a safe escort out of town for Floyd and Richetti. The next day, June 18, Miller took off, and Floyd and Richetti were whisked out of town by underworld figures on the nineteenth.

Miller's flight didn't last long. His dead and mutilated body was found near Detroit, Michigan, on November 22, 1933. He had apparently been executed gangland style.

Floyd and Richetti made their way to Buffalo, New York, and hid out in the area for over a year. In September 1934, Floyd was named Public Enemy Number 1 by the FBI. A month later, on October 19, the gangsters started on a trip west and had car trouble the next day in Ohio, where they

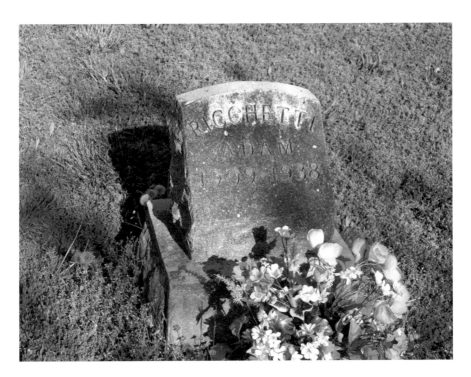

Adam Richetti grave in Bolivar, Missouri. *Photo by author.*

got into a shootout with law officers and Richetti was captured. Hunted down, Floyd was killed by officers in a second shootout two days later, on October 22. The FBI announced that the Kansas City Massacre case had officially been solved.

Richetti was convicted of first-degree murder in 1935 in connection with the massacre, and he was executed in the gas chamber at the Missouri State Penitentiary in Jefferson City in 1938. Several other men were convicted of conspiracy in the case for aiding and abetting the gunmen. Richetti was buried at his former hometown of Bolivar. For many years, flowers mysteriously appeared regularly on his grave, even though all of his family had long since moved away.

BIBLIOGRAPHY

Books and Magazine Articles

Brown, Cecil. *Stagolee Shot Billy*. Cambridge, MA: Harvard University Press, 2003.

Brundage, W. Fitzhugh. *Under Sentence of Death: Lynching in the South*. Chapel Hill: University of North Carolina Press, 1997.

Carney, Jessie. *Encyclopedia of African American Popular Culture*. Westport, CT: Greenwood Publishing Group, 2010.

Cases Determined by the St. Louis, Kansas City and Springfield Courts of Appeals of the State of Missouri. Vol. 180. Columbia, MO: E.W. Stephens Publishing Company, 1914.

Demuth, I. MacDonald. *The History of Pettis County, Missouri*. N.p.: F.A. North, 1882.

Flanders, Robert. "About This Issue: *OzarksWatch* on Law and Order." *OzarksWatch* 6, no. 3 (Winter 1993).

Frazier, Harriet C. *Slavery and Crime in Missouri*. Jefferson, NC: McFarland and Co., Inc., 2001.

Gilmore, Robert K. "An Ozarks Melodrama." *OzarksWatch* 6, no. 3 (Winter 1993).

History of Cole, Moniteau, Morgan, Benton, Miller, Maries and Osage Counties, Missouri. Chicago: Goodspeed Publishing Co., 1889.

History of Hickory, Polk, Cedar, Dade and Barton Counties, Missouri. Chicago: Goodspeed Publishing Co., 1889.

History of Laclede, Camden, Dallas, Webster, Wright, Texas, Pulaski, Phelps and Dent Counties, Missouri. 1889. Reprint, Independence, MO: BNL Library Service, 1974.

An Illustrated Historical Atlas Map of Jasper County, Missouri. N.p.: Brink, McDonough & Co., 1876.

King, Jeffery S. *The Life and Death of Pretty Boy Floyd.* Kent, OH: Kent State University Press, 1998.

Lay, James Henry. *A Sketch of the History of Benton County, Missouri.* Hannibal, MO: Winchell and Ebert Printing and Lithographing Company, 1876.

Livingston, Joel T. *A History of Jasper County and Its People.* Vol. 1. Chicago: Lewis Publishing Co., 1912.

McDonald, E.A. *Murder of the Meeks Family or Crimes of the Taylor Brothers.* Kansas City, MO: Ryan Walker, 1896.

———. *The Quadruple Murder: An Authentic Account of the Famous Meeks Family Murder and the Trial and Conviction of the Taylor Brothers.* Chillicothe, MO: Good Way Publishing, 1896.

North, F.A. *History of Jasper County, Missouri.* Des Moines, IA: Mills and Co., 1883.

Reports of Cases Determined in the Supreme Court of the State of Missouri at the April Term, 1896. Vol. 134. F.M. Brown, official reporter. Columbia, MO: E.W. Stephens, Publisher, 1897.

Settle, William A., Jr. *Jesse James Was His Name*. Columbia: University of Missouri Press, 1966.

Stiles, T.J. *Jesse James: Last Rebel of the Civil War*. New York: Alfred A. Knopf, 2002.

Southwestern Reporter. Vol. 225. St. Paul, MN: West Publishing Company, 1921.

Sturges, J.A. *Illustrated History of McDonald County, Missouri*. Pineville, MO, 1897.

Thomas, Clarke, and Jack Glendenning. *The Slicker War*. Aldrich, MO: Bona Publishing Co., 1984.

Unger, Robert. *The Union Station Massacre: The Original Sin of J. Edgar Hoover's FBI*. Kansas City, MO: Andrew McMeel Publishing, 1997.

Wallis, Michael. *Pretty Boy: The Life and Times of Charles Arthur Floyd*. New York: St. Martin's Press, 1992.

Waterman, D. Lee. *Bushwhacked: A True Tale of the Ozarks in 1880*. N.p.: CreateSpace Independent Publishing Platform, 2010.

Government Documents and Unpublished Manuscripts

Dipley, Walter. Pardon file. Missouri State Archives, Jefferson City.

Dipley, Walter, and Goldie Smith. Missouri Supreme Court appeal file. Missouri State Archives, Jefferson City.

Edwards, John Cummins. Governors Records (1844–48). Missouri State Archives, Jefferson City.

Headrick, John. Missouri Supreme Court appeal file. Missouri State Archives, Jefferson City.

Kansas City Massacre files. Federal Bureau of Investigation, Washington, D.C.

Ketchel, Stanley. Clippings. Springfield-Greene County Library.

Mann, Garland. Diary. Transcript copy provided by family descendants.

————. Missouri Supreme Court appeal file. Missouri State Archives, Jefferson City.

Martin, William F. Missouri Supreme Court appeal file. Missouri State Archives, Jefferson City.

Meeks, Gus. Pardon file. Missouri State Archives, Jefferson City.

Missouri death certificates. Missouri State Archives, Jefferson City.

Register of Inmates Received at the Missouri State Penitentiary. Missouri State Archives, Jefferson City.

Selby, Paul Owen. "The Meeks Family Murders." Unpublished manuscript. Photocopy in Linn County R-1 Schools Library.

Shelton, Lee. Pardon file. Missouri State Archives, Jefferson City.

U.S. census records.

Online Sources

"George William (Bill) Gillett Family History." www.genyourway.com/ms-1. html (accessed February 2, 2013).

"Murder By Gaslight: Frankie Baker—'He Done Her Wrong,'" http:// murderbygaslight.blogspot.com/2010/03/he-done-her-wrong.html (accessed February 22, 2013).

Slade, Paul. "A Christmas Killing: Stagger Lee," www.planetslade.com/ stagger-lee1.html (accessed April 4, 2013).

———. "It's a Frame-Up: Frankie & Johnny," www.planetslade.com/frankie-and-johnny1.html (accessed April 4, 2013).

St. Louis Police Veterans' Association, City of St. Louis Metropolitan Police Department, City of St. Louis, Missouri, Illustrated. "Chestnut Street Police Station and the Story of Stagger Lee," www.slpva.com/historic/police220chestnut.html (accessed February 20, 2013).

———."Kiel Opera House and Four Courts and the Story of Frankie and Johnny," www.slpva.com/historic/police212targee.html (accessed February 20, 2013).

Newspapers

Anderson (SC) Intelligencer
Bolivar Free Press
Bolivar Herald
Boon's Lick Times
Cape Girardeau Democrat
Carrollton Daily Democrat
Carthage Mornin' Mail
Eminence Current Wave
Jackson Cash Book
Joplin Daily Herald
Kansas City Star
Lebanon Daily Rustic Leader
Lebanon Rustic
Lebanon Rustic Leader
Liberty Tribune
Marshfield Mail
Milan Republican
Milan Standard
Mountain View Standard
Neosho Miner and Mechanic
Neosho Times

BIBLIOGRAPHY

New York Times
Pineville News
Sedalia Weekly Bazoo
Springfield Advertiser
Springfield Daily Leader
Springfield Express
Springfield Missouri Weekly Patriot
Springfield Patriot Advertiser
Springfield Republican
St. Joseph Evening News
St. Louis Globe-Democrat
St. Louis Post-Dispatch
St. Louis Republic
Van Buren Current Local
Weekly Chillicothe Crisis

INDEX

INDEX

ABOUT THE AUTHOR

Larry Wood is a retired public school teacher and a freelance writer. His historical articles have appeared in numerous publications, including *America's Civil War*, *Blue and Gray*, *Gateway Heritage*, *Missouri Life*, *Missouri Historical Review*, the *Ozarks Mountaineer*, *True West*, and *Wild West*. His titles *Civil War Springfield*, *The Two Civil War Battles of Newtonia*, *Wicked Joplin*, and *Wicked Springfield, Missouri* are available from The History Press. A native of Fair Grove, Missouri, Wood received his bachelor's and master's degrees from Missouri State University and now lives in Joplin with his wife, Gigi.

Visit us at
www.historypress.net
..
This title is also available as an e-book